legends

legends

WOMEN WHO HAVE CHANGED THE WORLD

THROUGH THE EYES OF GREAT WOMEN WRITERS

Edited by JOHN MILLER

Introduction by ANJELICA HUSTON

NEW WORLD LIBRARY
NOVATO, CALIFORNIA

 New World Library
14 Pamaron Way
Novato, CA 94949

New World Library is dedicated to publishing books and cassettes that inspire and challenge us to improve the quality of our lives and our world.

Phone: (415) 884-2100 • Or toll-free: (800) 972-6657

Cover photograph of Audrey Hepburn © 1954 by Cecil Beaton
Back cover photograph of Frida Kahlo courtesy of Corbis-Bettmann
Legends was packaged by Big Fish / www.theonethatgotaway.com

Design and Editorial: John Miller and Aaron Kenedi
New World Library Editors: Becky Benenate and Jason Gardner
Production: Eleanor Reagh
Research: Christy Arceo

Library of Congress Cataloging-in-Publication Data

Legends : women who have changed the world through the eyes of great women writers / edited by J. Miller : introduction by Anjelica Huston.
 p. cm.
 ISBN 1-57731-042-X (hardcover: acid-free paper)
 ISBN 978-1-57731-183-6 (paperback: acid-free paper)
 1. Women—Biography. 2. Biography—20th century. I. Miller, John, 1959–
 CT3235.L44 1998 98-16225
 920.72'09'04—dc2I CIP

First printing, November 1998
First paperback printing, August 2001
Printed in China on acid-free paper
ISBN 978-1-57731-183-6
Distributed to the trade by Publishers Group West

20 19 18 17 16 15 14 13 12

to the love of my life

k

contents

legends

introduction

by ANJELICA HUSTON

IT'S NOT IMPORTANT that we know everything about the women gathered in this collection. It's not even necessary that we like them or what they stood for. By their very nature, these are bold, courageous, often controversial figures who, over the course of the last century, have aggressively stamped their names into the pages of history.

What *is* important is that we appreciate each for accomplishing something truly monumental; for challenging the status quo; for rebelling at the perfect time; for heralding a message or idea that perhaps the world was unprepared to hear, but for which, in the long run, it was undeniably better off. In short, they are women to be thankful for.

During the 1950s, in the idyllic afterglow of World War II, who could have dreamed up a Marilyn Monroe? Surely not even Norma Jean could have predicted her poignant, passionate—and doomed—life. We may not have been prepared for her assault on the world's sexual myopia, but to imagine a world in which she never existed seems difficult even to attempt. And what about Virginia Woolf, whose own torrid battle with the constraints of society led to questionable and sometimes pernicious acts, but whose talent was so overwhelming that she pioneered a whole movement in literature?

Of course, not all of the women gathered here have reached the status of Monroe and Woolf, but that does not argue against their place in history. In a certain way, the ripples of their impact are just as strongly felt, for better or ill. Were it not for Twiggy, the entire fashion industry would have a completely different face (and figure). And Babe Zaharias most certainly paved the way for generations of women to enter athletics.

Some women hurdled not just gender and social boundaries but also race barriers. For a black woman in the 1940s to achieve Billie Holiday's fame and admiration, she had to best unbelievable odds. And often, those odds took their toll. These were great and tough women, but their humanness and frailty were also very real. Holiday, Monroe, Woolf, and others battled through agonizing, even fatal, drug and alcohol addictions. The magnitude of their fame, no matter how satisfying, never ceased to weigh on them. Perhaps what separates these women from other popular female figures in history is their determination to fight through these obstacles and transcend popular conceptions of their gender. And at the same time, to acquiesce to and participate in the frenzy they created.

The process of creativity is not always a pleasant one and not all of these women were pleasant. The world of dance owed Martha Graham much gratitude for her progressive contributions, but as Alma Guillermoprieto suggests with a mixture of reverence and thinly veiled horror, she could also be a "sacred monster." And there is palpable sadness (and gripping irony) in Mary Jo Salter's recounting of Helen Keller's wrenching fear that her education, which she considered gospel and depended on for sanity, may have been little more than misguided rote, passed down by her mentor.

Regardless, each of these women has somehow tapped into something awe inspiring and timeless, something beyond the scope of celebrity. Maybe the best term to use for them is legendary. These are women whom generation after generation will tell their children about. They are characters; icons; women of strength, beauty, conviction, determination, and nerve.

Legends is not a series of puff pieces designed to serve the cause of womanhood. Rather, these are skillfully revealing, candid portraits that describe their subjects through the unique and human details that defined their lives. The result is one of the most inspirational gatherings of women ever—a vibrant and provocative anthology of grace and style as impressive and compelling as the personalities who inhabit its pages.

amelia earhart

by CAMILLE PAGLIA

AMELIA EARHART SYMBOLIZES modern woman's invasion of the male world of daring adventure. As an aviator, she broke barriers and made the machine age her own. As a recreational athlete and automobile driver, she embodied fitness, energy, and breezy mobility.

The tall, shy, boyish Earhart was dubbed "Lady Lindy" after a 1928 flight that made her the first woman to cross the Atlantic by air, although she was little more than a passenger. Four years later, determined to prove her mettle, Earhart became the first woman to fly the Atlantic solo, overcoming near-fatal weather hazards and equipment failure. Until her strange disappearance in the Pacific after a trouble-plagued around-the-world flight in 1937, Earhart was probably the most famous woman in the world and a constant presence in the media. Dashing in man-tailored shirts, jackets, and slacks, Earhart epitomized the rapidly evolving new woman who sought self-definition and fulfillment outside the home. Her ability to open her mysterious, poetic inner self to the camera lens was as advanced as any movie star's.

In 1961, at age 14, I saw an article about Earhart in a Syracuse newspaper and had a stunning conversion experience. Marooned in a desert of perky blondes (Doris Day, Debbie Reynolds, Sandra Dee), I was in wild adolescent revolt against American sex roles. Earhart's life was a revelation. Through her and Katharine Hepburn, I discovered the achievements of women in the 1920s and '30s, who swept into amazing visibility after the passage of suffrage. I embarked on an obsessive three-year research project on Earhart with the aim of producing a book that would celebrate her as a model of the liberated woman. I ransacked libraries, wrote hundreds of letters, and met Earhart's sister near Boston. A curator of the National Air and Space Museum opened a safe to show me Earhart's medals and other personal effects. At Movietonews in New York, I was given a private showing of Earhart newsreels. On family car trips, I visited Earhart's birthplace in Kansas and the obscure field near Miami where she began her last flight. At Purdue University, I tried on her battered leather jacket.

By vanishing into thin air, Amelia Earhart seemed to merge with the elements of nature, which she had so often challenged and conquered. She became the archetype of the androgynous winged seraph who escapes the bondage of reproduction and biology. For me, she represented high aspiration and freedom of thought. Hers was a mature, enlightened feminism that never indulged in shallow male-bashing. She enjoyed an easy companionship with men, from mechanics to presidents. She respected the greatness of what men had achieved and simply desired to show that women could perform just as well or better. And she believed that leading by example would systematically transform society.

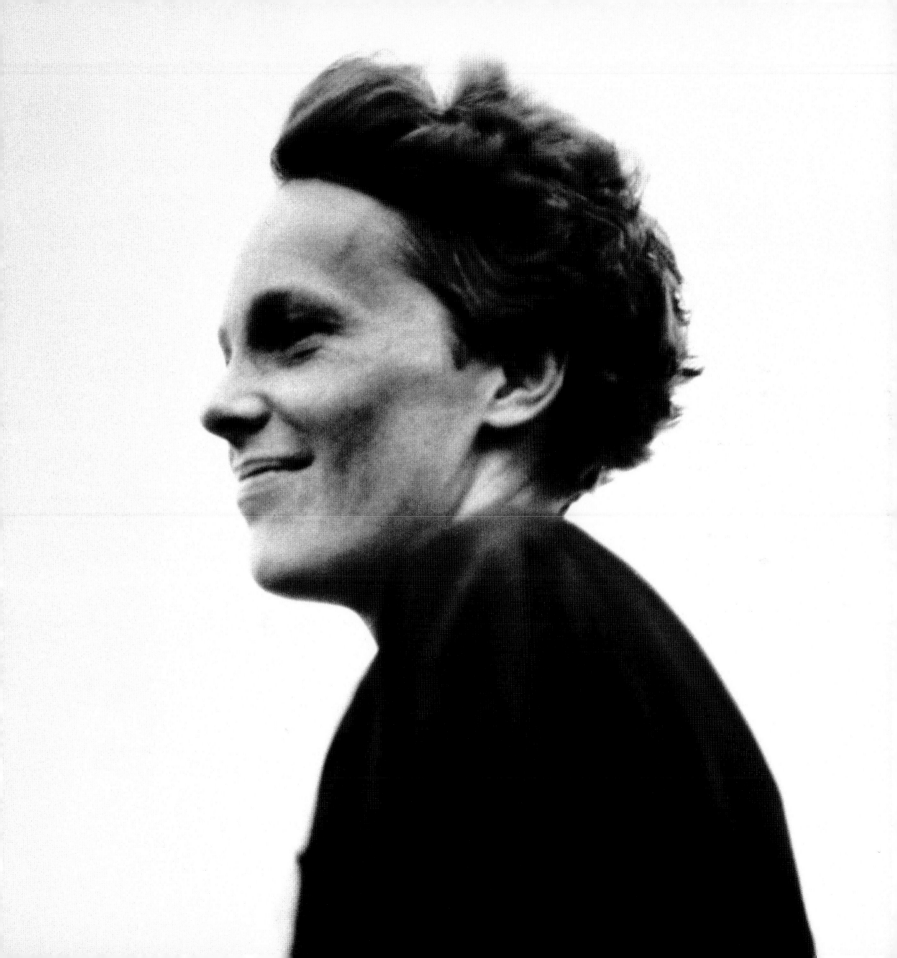

billie holiday

by ELIZABETH HARDWICK

THE SHIFTY JAZZ CLUBS on 52nd Street. The Onyx, the Down Beat, the Three Deuces. At the curb, getting out of a taxi, or at the White Rose Bar drinking, there "they" were, the great performers with their worn, brown faces, enigmatic in the early evening, their coughs, their broken lips and yellow eyes; their clothes, crisp and bright and hard as the bone-fibered feathers of a bird. And there she was—the "bizarre deity," Billie Holiday....

She was fat the first time we saw her, large, brilliantly beautiful, fat. She seemed for this moment that never again returned to be almost a matron, someone real and sensible who carried money to the bank, signed papers, had curtains made to match, dresses hung and shoes in pairs, gold and silver, black and white, ready. What a strange, betraying apparition that was, madness, because never was any woman less a wife or mother, less attached; not even a daughter could she easily appear to be. Little called to mind the pitiful sweetness of a young girl. No, she was glittering, somber, and solitary, although of course never alone, never. Stately, sinister, and absolutely determined.

The creamy lips, the oily eyelids, the violent perfume—and in her voice the tropical l's and r's. Her presence, her singing created a large, swelling anxiety. Long red fingernails and the sound of electrified guitars. Here was a woman who had never been a Christian....

In her presence on these tranquil nights it was possible to experience the depths of her disbelief, to feel sometimes the mean, horrible freedom of a thorough suspicion of destiny. And yet the heart always drew back from the power of her will and its engagement with disaster. An inclination bred upon punishing experiences compelled her to live gregariously and without affections. Her talents and the brilliance of her mind contended with the strength of the emptiness. Nothing should degrade this genuine nihilism; and so, in a sense, it is almost a dishonor to imagine that she lived in the lyrics of her songs.

Her message was otherwise. It was *style*. That was her meaning from the time she began at fifteen. It does not change the victory of her great effort, of the miraculous discovery or retrieval from darkness of pure style, to know that it was exercised on "I love my man, tell the world I do...." How strange it was to me, almost unbalancing, to be sure that she did not love any man, or anyone. Also often one had the freezing perception that her own people, those around her, feared her. One thing she was ashamed of—or confused by, rather—that she was not sentimental....

Her whole life had taken place in the dark. The spotlight shone down on the black, hushed circle in a café; the moon slowly slid through the clouds. Night-working, smiling, in make-up, in long, silky dresses, singing over and over, again and again. The aim of it all is just to be drifting off to sleep when the first rays of the sun's brightness threaten the theatrical eyelids.

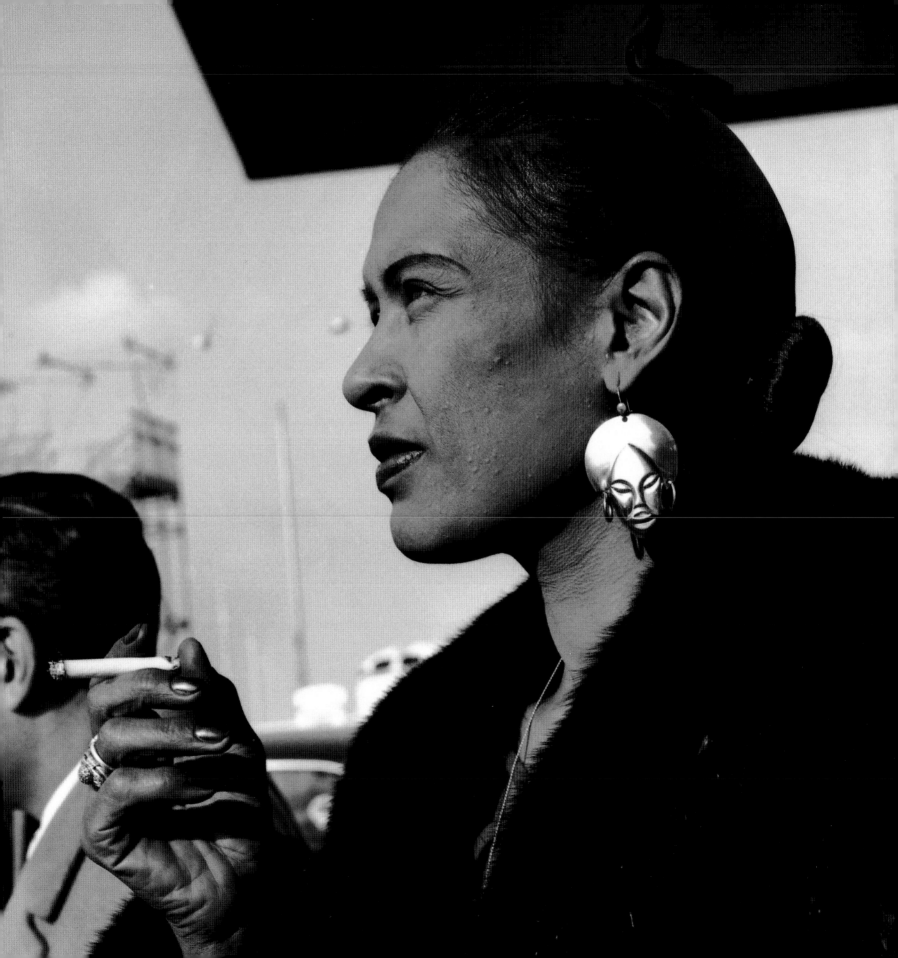

georgia o'keeffe

by JOAN DIDION

"WHERE I WAS BORN and where and how I have lived is unimportant," Georgia O'Keeffe told us in the book of paintings and words published in her ninetieth year on earth. She seemed to be advising us to forget the beautiful face in the Stieglitz photographs. She appeared to be dismissing the rather condescending romance that had attached to her by then, the romance of extreme good looks and advanced age and deliberate isolation. "It is what I have done with where I have been that should be of interest."...

Some women fight and others do not. Like so many successful guerrillas in the war between the sexes, Georgia O'Keeffe seems to have been equipped early with an immutable sense of who she was and a fairly clear understanding that she would be required to prove it. On the surface her upbringing was conventional. She was a child on the Wisconsin prairie who played with china dolls and painted watercolors with cloudy skies because sunlight was too hard to paint and, with her brother and sisters, listened every night to her mother read stories of the Wild West, of Texas, of Kit Carson and Billy the Kid. She told aunts that she wanted to be an artist and was embarrassed when they asked what kind of artist she wanted to be: she had no idea "what kind."... At thirteen, in a Dominican convent, she was mortified when the sister corrected her drawing. At Chatham Episcopal Institute in Virginia she painted lilacs and sneaked time alone to walk out to where she could see the line of the Blue Ridge Mountains on the horizon. At the Art Institute in Chicago she was shocked by the presence of live models and wanted to abandon anatomy lessons. At the Art Students League in New York one of her fellow students advised her that, since he would be a great painter and she would end up teaching painting in a girls' school, any work of hers was less important than modeling for him. Another painted over her work to show her how the Impressionists did trees. She had not before heard how the Impressionists did trees and she did not much care.

At twenty-four she left all those opinions behind and went for the first time to live in Texas, where there were no trees to paint and no one to tell her how not to paint them. In Texas there was only the horizon she craved. In Texas she had her sister Claudia with her for a while, and in the late afternoons they would walk away from town and toward the horizon and watch the evening star come out. "That evening star fascinated me," she wrote. "It was in some way very exciting to me. My sister had a gun, and as we walked she would throw bottles into the air and shoot as many as she could before they hit the ground. I had nothing but to walk into nowhere and the wide sunset space with the star. Ten watercolors were made from that star."...

helen keller

by MARY JO SALTER

S HE REMAINS NOT QUITE 7 years old for many of us, suspended in the revelatory moment in 1887 that crowns William Gibson's play *The Miracle Worker.* Helen Keller stands ignorant at the pump while her teacher, Annie Sullivan, works it rapidly, and with the simultaneous spilling of water and spelling of water into her palms, she suddenly intuits that everything on this earth has a name. The well of knowledge! Still a child when I first watched a child actress enacting Helen's real-life epiphany, I hardly understood the well's literary aptness. But Helen's cry—that elemental wa—pumped water up from some deep source into my own eyes and briefly blinded them.

It's doubtful that a good play will ever be written about the next discovery, thrilling but messy, in Helen Keller's life. She learned that everything does not have a name; it has many. Long before she entered Radcliffe in 1900, she had mastered the manual alphabet and manual lip-reading and the typewriter and several forms of Braille, in which she read Greek and Latin and French and German. By the time of her cum laude graduation (she'd gone through in four years, like everybody else—though perhaps unlike them she had already published her autobiography), she was still struggling with her most difficult language of all: speech. Even her friends said she spoke as with an unidentifiable foreign accent.

What country was Helen Keller from? People felt she hailed from Heaven—which was a mixed blessing. Idolized for her angelic temperament, her courage and joy and generosity, she played unwittingly into the hands of those who would sentimentalize all women as better than men, too saintly to be shown the whole picture. Even her great friend, the unsentimental Mark Twain, said he was certain Keller's inner visions were more beautiful than reality.

Yet an ugly suspicion lodged at the core of Keller's life. At 11, she unconsciously plagiarized a story she'd been told, and never again would she be entirely confident about which of her ideas were her own. As a world-famous adult, she read arguments by educators and psychologists that her very self was in some way not her own but the gifted Sullivan's—handed down, as it were. By writing beyond her direct experience, with words like "pink" or "whisper," had Keller erected a wall of conventionality that effectively shut her soul off from knowing itself? Nearing 50, she wrote defiantly that she took solace in Descarte's dictum, "I think, therefore I am." But one fears she was never sure.

Her valiant life continues to raise complex questions—about dependency, originality, the development of the brain. Thinking about her, one's own brain goes only so far. Those of us with five senses are missing a sense of how Helen Keller thought with three.

audrey hepburn

by DIANE JOHNSON

EVERYONE WAS IN LOVE with this beautiful gazelle of an actress, but none of her qualities—innocence, freshness, unspoiled charm, grace, aristocratic bearing—seem to entirely explain her popularity. Certainly not innocence, since she often played rather sophisticated and knowing young women, like Holly Golightly. The fresh beauty that everyone responded to was not quite it, either. Elegance comes closer—that joyous lightness of touch and piquant slenderness that contrasted so tellingly with the heavier, more voluptuous Marilyn, Lana, or Ava.

Audrey was admired for her accomplishments—poise, grooming, wit, style, and a knowledge of foreign languages; she could probably play the piano too. We knew she had studied ballet, though she seldom danced. Her allure was not the boring virtue of girl-next-door types like Doris Day or Sally Field. Like a true princess—England's indubitably royal Elizabeth and Margaret, for instance—she had an unassailable qualification for our adoration: she was not American.

Young women in this country knew that they could never "be" Audrey Hepburn (and men could never "have" her) for one main reason: we were not Continental. Audrey Hepburn focused all our American longing for sophisticated worldliness. Any of us might grow up to be polite and pretty, and we might even become actresses. But nothing could make us into aristocratic Europeans, because we were American teenagers, doomed by democracy.

What's more, she was unsoiled by Hollywood. Most of the great stars had scrabbled to the top in a variety of sordid ways, dodging lecherous stepfathers and abusive uncles and negotiating the casting couch. If Audrey had to do any of that, it was not known. On the other hand, if in the classic Freudian opposition of Madonna and whore, she only represented the Madonna, young women would not have admired her so whole-heartedly, for it does not escape any woman, however unconsciously, that the Madonna role is both demanding and thankless. . . .

Whatever Audrey Hepburn's private life, it did not matter, though nothing that we knew of it disturbed our idea of her either, because her status ultimately derived from her roles in films like *Roman Holiday, Charade, Funny Face, Sabrina, Love in the Afternoon,* and *Breakfast at Tiffany's.* In these, she played prized females who prevailed. . . . Sums had been lavished on her clothes by Balenciaga or Givenchy. The most important thing about her was not that she was "radiant" or "untouched," it was that she was valuable and *treasured.*

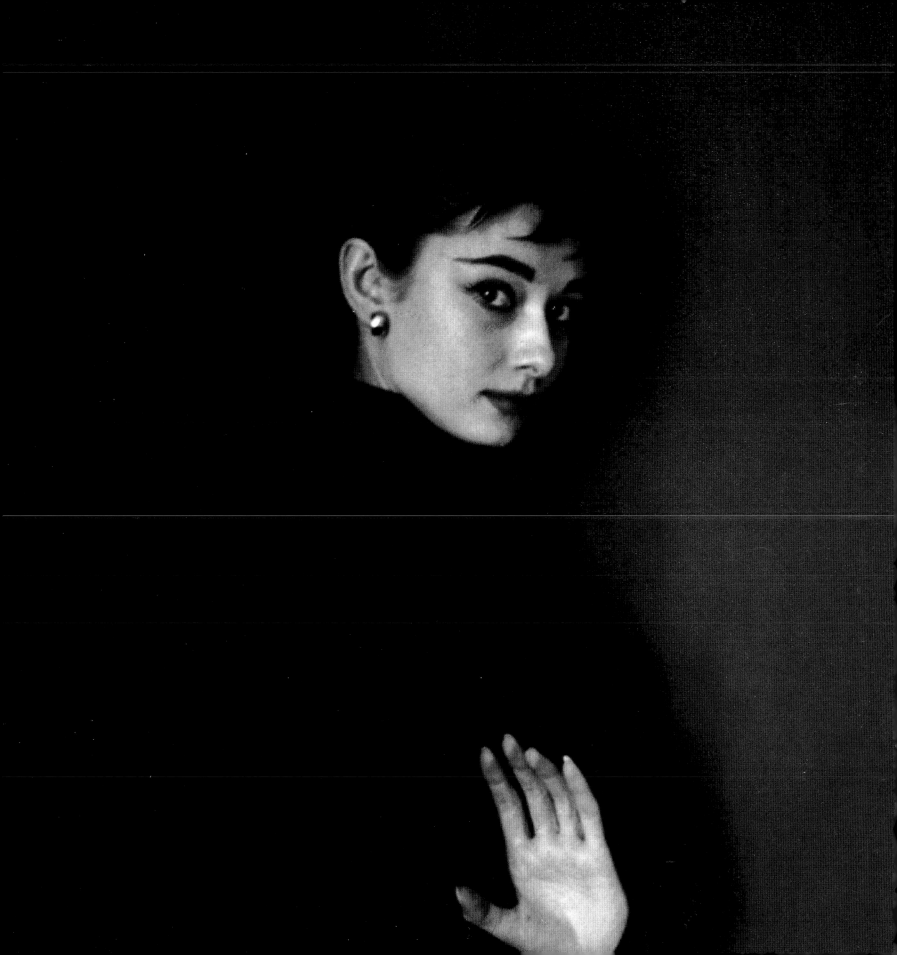

susan sontag

by LARISSA MACFARQUHAR

IN 1968, AT 35, Sontag was both a popular icon and one of the country's most respected critics. She wrote for *Partisan Review* and *Esquire,* for *Mademoiselle* and *The New York Review of Books.* She had published her first novel, *The Benefactor,* in 1963, her second, *Death Kit,* in 1967, and her first essay collection, *Against Interpretation,* in 1966. Reading it now, you can sense how exciting it must have been to pick up *Against Interpretation* in 1966, when it was unexpected: those luscious sentences, those enticing paragraphs and that curious, appreciative, calm, intelligent, *innocent* voice, without a trace of knowingness or sarcasm, that skipped so easily between flirtatious epigrams and earnest reasoning.

At the time, compared with Stalin-era types, Sontag was indeed a girl of the *Zeitgeist.* She had rallied against traditional, literary interpretation and condemned it as "reactionary," "cowardly," and "stifling." She had resuscitated Antonin Artaud by favoring spectacle over psychologizing in art, and proclaimed the "new sensibility" to be exemplified by visual arts like cinema, dance, and painting—not novels. Rejecting Clement Greenberg's and Dwight Macdonald's efforts to put a *cordon sanitaire* around the avant-garde, she had attached quotation marks to "high" and "low" culture and declared the distinction practically meaningless ("The feeling...given off by a Rauschenberg painting might be like that of a song by the Supremes"). She had infamously declared the white race to be "the cancer of human history" and concluded that "Mozart, Pascal, Boolean algebra, Shakespeare, parliamentary government, baroque churches, Newton, the emancipation of women, Kant, Marx, and the Balanchine ballets don't redeem what this particular civilization has wrought upon the world." ...

She agreed with Lionel Trilling, for instance, that art could and should have moral effect on consciousness, but she thought that that effect could be derived from the most disengaged, aesthetic kinds of experience. She looked for self-transcendence, yes, but she found it in pornography (though only of the most highbrow sort)....

By the late seventies and early eighties, though, Sontag's perspective had shifted. By the time she began writing the essays that would constitute *On Photography* (1977), she had become much warier of the dehumanizing, morally neutralizing quality of the sensuous-formalist ways of thinking that she had relished before....

So much of her writing consists of, as she put it, "case studies of [her own] evolving sensibility." After all, as she wrote admiringly of fellow-generalist Roland Barthes on his death in 1980, "It was not a question of knowledge...but of alertness, a fastidious transcription of what *could* be thought about something, once it swam into the stream of attention."

zora neale hurston

by ALICE WALKER

A FRIEND OF MINE called one day to tell me that she and another woman had been discussing Zora Neale Hurston and had decided they wouldn't have liked her. They wouldn't have liked the way—when her play *Color Struck!* won second prize in a literary contest at the beginning of her career—Hurston walked into a room full of her competitors, flung her scarf dramatically over her shoulder, and yelled "COLOR..R.R STRUCK..K.K!" at the top of her voice.

Apparently it isn't easy to like a person who is not humbled by second place. Zora Neale Hurston was outrageous—it appears by nature. She was quite capable of saying, writing, or doing things *different* from what one might have wished. Because she recognized the contradictions and complexity of her own personality, Robert Hemenway, her biographer, writes that Hurston came to "delight" in the chaos she sometimes left behind.

Yet for all her contrariness, her "chaos," her ability to stir up dislike that is as strong today as it was fifty years ago, many of us love Zora Neale Hurston. We do not love her for her lack of modesty...we do not love her for her unpredictable and occasionally weird politics (they tend to confuse us); we do not, certainly, applaud many of the *mad* things she is alleged to have said and sometimes actually did say; we do not even claim never to dislike her. In reading through the thirty-odd-year span of her writing, most of us, I imagine, find her alternatively winning and appalling, but rarely dull, which is worth a lot. We love Zora Neale Hurston for her work, first, and then again, ...we love her for herself. For the humor and courage with which she encountered a life she infrequently designed, for her absolute disinterest in becoming either white or bourgeois, and for her devoted appreciation of her own culture, which is an inspiration to us all.

Reading *Their Eyes Were Watching God* for perhaps the eleventh time, I am still amazed that Hurston wrote it in seven weeks; that it speaks to me as no novel, past or present, has ever done; and that the language of the characters, that "comical nigger 'dialect'" that has been laughed at, denied, ignored, or "improved" so that white folks and educated black folks can understand it, is simply beautiful. There is enough self-love in that one book—love of community, culture, traditions—to restore a world. Or create a new one....

Zora Neale Hurston, who went forth into the world with one dress to her name, and who was permitted, at other times in her life, only a single pair of shoes, rescued and recreated a world which she labored to hand us whole, never underestimating the value of her gift, if at times doubting the good sense of its recipients. She appreciated us, in any case, *as we fashioned ourselves.* That is something. And of all the people in the world to be, she chose to be herself, *and more and more herself.* That, too, is something.

marilyn monroe

by GLORIA STEINEM

THE *MISFITS* SEEMED to convey some facets of the real Marilyn: honesty, an innocence and belief that survived all experience to the contrary, kindness toward other women, a respect for the life of plants and animals. Because for the first time she wasn't only a sex object and victim, I also was unembarrassed enough to notice her acting ability. I began to see her earlier movies—those few in which, unlike *Gentlemen Prefer Blondes,* she wasn't called upon to act the female impersonator.

For me as for so many people, she was a presence in the world, a life force.

Over the years, I heard other clues to her character. When Ella Fitzgerald, a black artist and perhaps the greatest singer of pop songs, hadn't been able to get a booking at an important Los Angeles nightclub in the fifties, it was Marilyn who called the owner and promised to sit at a front table every night if he allowed Ella to sing. The owner hired Ella, Marilyn was faithful to her promise and each night, the press went wild, and, as Ella remembered with gratitude, "After that, I never had to play a small jazz club again."

Even more movingly, there was Marilyn's last interview. She pleaded with the reporter to end with, "What I really want to say. That what the world really needs is a real feeling of kinship. Everybody: stars, laborers, Negroes, Jews, Arabs. We are all brothers.... Please don't make me a joke. End the interview with what I believe."...

Now that women's self-vision is changing, we are thinking again about the life of Marilyn Monroe. Might our new confidence in women's existence with or without the approval of men have helped a thirty-six-year-old woman of talent to stand on her own?...

Most of all, we wonder if the support and friendship of other women could have helped. Her early experiences of men were not good. She was the illegitimate daughter of a man who would not even contribute for her baby clothes; her mother's earliest memory of her own father, Marilyn's grandfather, was his smashing a pet kitten against the fireplace in a fit of anger; Marilyn herself said she was sexually attacked by a foster father while still a child; and she was married off at sixteen because another foster family could not take care of her. Yet she was forced always to depend for her security on the goodwill and recognition of men; even to be interpreted by them in writing because she feared that sexual competition would make women interviewers dislike her. Even if they had wanted to, the women in her life did not have the power to protect her. In films, photographs, and books, after her death as well as before, she has been mainly seen through men's eyes.

We are too late. We cannot know whether we could have helped Norma Jeane Baker or the Marilyn Monroe she became. But we are not too late to do as she asked. At last, we can take her seriously.

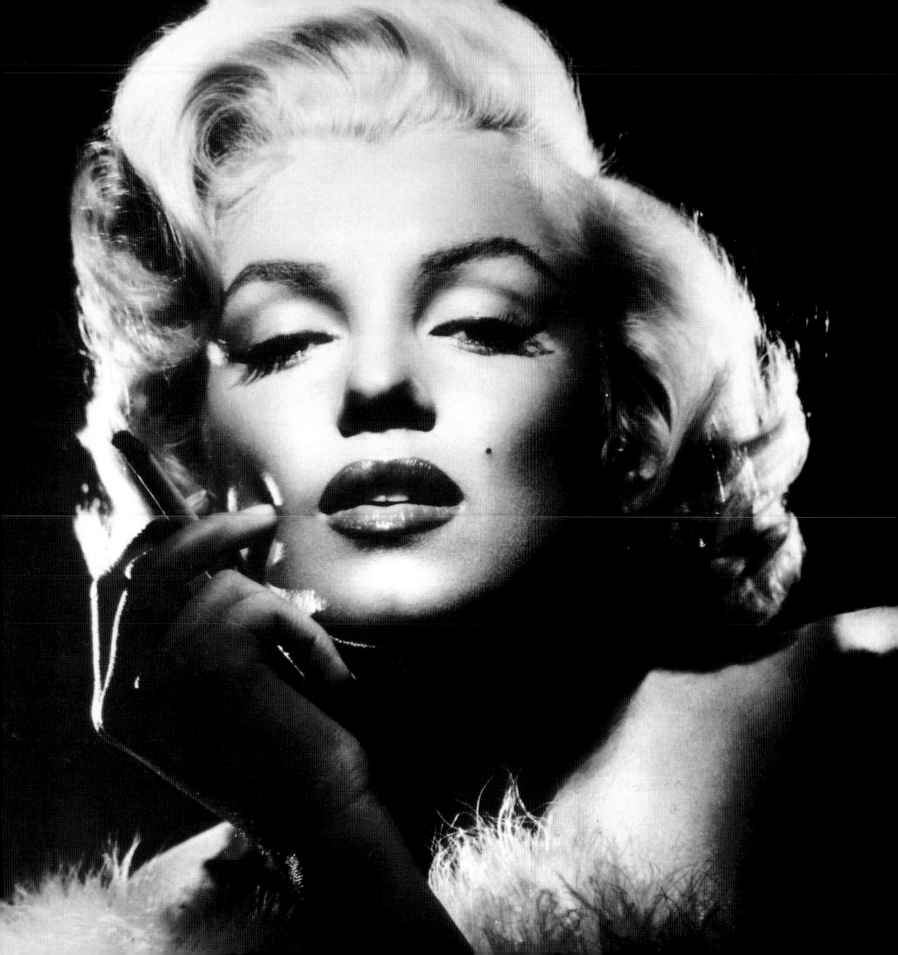

rachel carson

by TERRY TEMPEST WILLIAMS

RACHEL CARSON. I first heard her name from my grandmother. I must have been seven or eight years old. We were watching birds—goldfinches and towhees—in my grandparents' garden. "Imagine a world without birds," my grandmother said. "Imagine waking up to no birdsong." I couldn't.

"Rachel Carson," I remember her saying. "*Silent Spring.*" And then she and my grandfather engaged in a deeper discussion as my mind tried to grasp what my grandmother had just said.

Thirty years later, I find myself in a used bookstore in Salt Lake City. The green spine of *Silent Spring* catches my eye. I pull the classic off the shelf and open it. First edition, 1962. As I reread the text, I am struck by how little has changed:

> One of the most tragic examples of our unthinking bludgeoning of the landscape is to be seen in the sagebrush lands of the West, where a vast campaign is on to destroy the sage and to substitute grasslands. If ever an enterprise needed to be illuminated with a sense of history and meaning of the landscape, it is this.... It is spread before us like the pages of an open book in which we can read why the land is what it is, and why we should preserve its integrity. But the pages lie unread....

Rachel Carson told the truth as she saw it. The natural world was dying, poisoned by the hands of corporate greed. Her words became a catalyst for change. A debate had begun: a reverence for life versus a reverence for power. Through the strength and vitality of her voice, Carson altered the political landscape of America.

In 1967, five years after *Silent Spring* was published, the Environmental Defense Fund was born, with a mandate, in the words of one of its founders, "to build a body of case law to establish a citizen's right to a clean environment." Three years later, in 1970, the Environmental Protection Agency was established....

I want to remember Rachel Carson's spirit. I want to be both fierce and compassionate at once. I want to carry a healthy anger inside of me and shatter the complacency that has seeped into our society. I want to know the grace of wild things that sustains courage. Writer Jack Turner calls for a "sacred rage," a rage that is grounded in the holy knowledge that all life is related. Can we find the moral courage and sacred rage within ourselves to step forward and question every law, person, and practice that denies justice toward nature? Can we continue to bear witness?

This is the message of *Silent Spring.* Carson tells us, "The history of life on earth has been a history of interaction between living things and their surroundings." ...

I realize the innocence of those days. Now the idea of a spring without birdsong is indeed imaginable. Rachel Carson has called us to action. Her words remain as sacred text.

twiggy

by SUSAN CHEEVER

THERE WAS A TIME when dinosaurs walked the earth. You could usually find them in the kitchen. They had curvy bodies and fleshy, deliciously rounded arms and shoulders, and you could hear them coming by the reassuring click, click, click of their heels. They were skilled in the Stone Age arts of ironing and mending and comforting their young.... Their pointy bras and prehistoric girdles created artificial shapes with tiny midsections, but under their shirtwaist dresses their bodies were natural, built for hugging and for eating homemade gingersnaps right off the cookie sheet. Back in the land before time, when big breasts were more important than thin thighs, the ideal woman was an hourglass with wavy hair, a pretty name and a nurturing soul, a woman as sexy as Marilyn and as demure as Jacqueline. It was 1967.

Then came Twiggy.

Twiggy landed at Kennedy airport in March 1967, in the spring of the Summer of Love; she got famous so fast that when she was first asked for an interview, she didn't know what an interview was.... Twiggy became an instant icon, a symbol for a new kind of woman with a new kind of streamlined, androgynous sex appeal. She was the bodiless embodiment of a different way of looking and dressing and the different way of living that went with it.

In one way, the changes meant freedom. The new woman was a professional as well as a domestic—she had an economic and sartorial independence unheard of in the 1950s. She could travel alone and know the joys of providing for a family, and if she wanted to, she could hire someone to bake her cookies and comfort her children.

The freedom came with a set of draconian standards—not the least of which was a body type that is an impossible dream for most women over 30. In the 1960s, the average fashion model was 15 pounds lighter than the average woman; in the 1990s, the average fashion model is 35 pounds lighter and four inches taller than the average woman. Our ideal has left our reality in the dust. Even Twiggy was a harbinger of the low self-esteem to come. "I hated the way I looked then," she says of her 1967 self. These days we don't have to wear shirtwaists and lipstick and we do our own hair, but many of us have jeopardized our health and sanity in a desperate struggle to be thinner. We new women earn a lot of money; we spend a huge percentage of it trying to lose weight.

The icon leads one life and the real person leads another. The real Twiggy went on to grow up, gain weight, get married, star in a musical with Tommy Tune, have a daughter, move to Los Angeles, and play Princess Georgina La Rue in the 1991 sitcom "Princesses." Now she lives in the Kensington section of London with her second husband, the actor Leigh Lawson. She's a slender 47-year-old with long hair; her friends call her Twigs. She's working on a television movie and writing her as yet untitled autobiography. Let's hope she tells us all to relax.

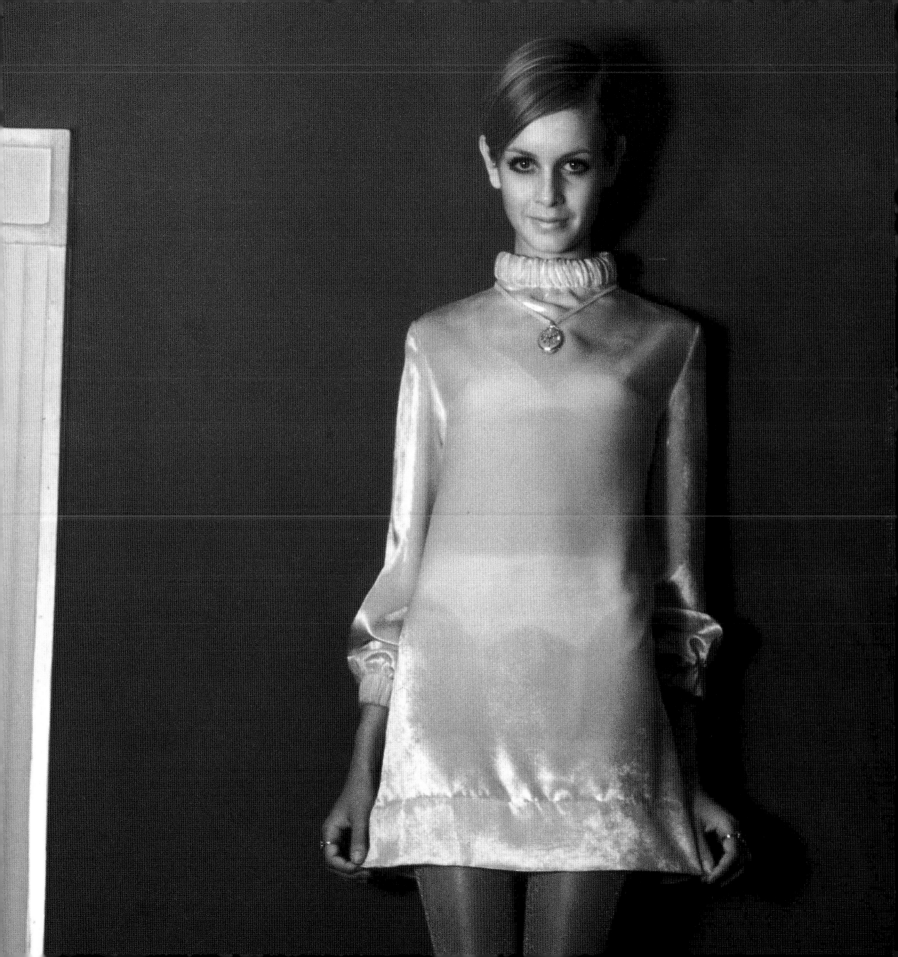

mother teresa

by BECKY BENENATE

ON SEPTEMBER 10, 1946, Agnes Bojaxhiu, now known and loved by millions as Mother Teresa of Calcutta, first heard an inner calling to leave her convent and commit herself to helping the poorest of the poor by living and working among them. After receiving special permission from the Vatican to live outside the convent, she took off her religious habit and donned a white sari—the same sari worn by the poorest women in India. She began by teaching orphaned children in a slum school in Motijhil, India, using the ground as her chalkboard.

As she taught, she began caring for the sick. Coming across a dying woman on the street, she carried her to a local hospital for care. Because the woman was poor, the hospital refused to admit her, and she died on the street. Mother Teresa knew then that she had to make a home for India's sick and dying—a place for them to die with dignity, love, and grace.

After years of pleading for a home, she was finally able to rent two small huts. One became a school for orphans, the other, her first home for the sick and dying. Her compassion and commitment to her work inspired thousands of sisters and other volunteers to join her. The order of the Missionaries of Charity was established on July 10, 1950. Today there are more than 500 homes for the sick and dying all over the world. Through her humble example, Mother Teresa shared her heart with millions, and inspired them to love the world's forgotten and neglected.

Despite her great work, however, Mother Teresa didn't escape controversy. She openly and gratefully accepted donations on behalf of the Missionaries of Charity without concern for the donor's background. She gave love to children with the conviction of her heart—firmly committed to preserving the gift of life for the born and unborn. Her views on abortion were not always popular, and were seen by some as harmful. But they came from a singular concern for life. When we look at the heart of the controversy, we see that in her faith and life purpose were incredible lessons of love, commitment, and service. And we see that she brought hope and love into the lives of millions.

Like so many others whose paths she crossed, Mother Teresa came into my life when I needed her most. Working with her words and embracing her wisdom sparked my own faded memories of faith during a time of immense confusion, loss, and heartache. I am grateful for the opportunity I had to learn from her—to feel her compassion and strength. She reminded me of the importance of silence, and taught me that in the silence of the heart, God speaks.

Mother Teresa quietly passed away when the world was mourning the death of Princess Diana. But in the hearts of millions of people from all over the world and from all walks of life, Mother lives on.

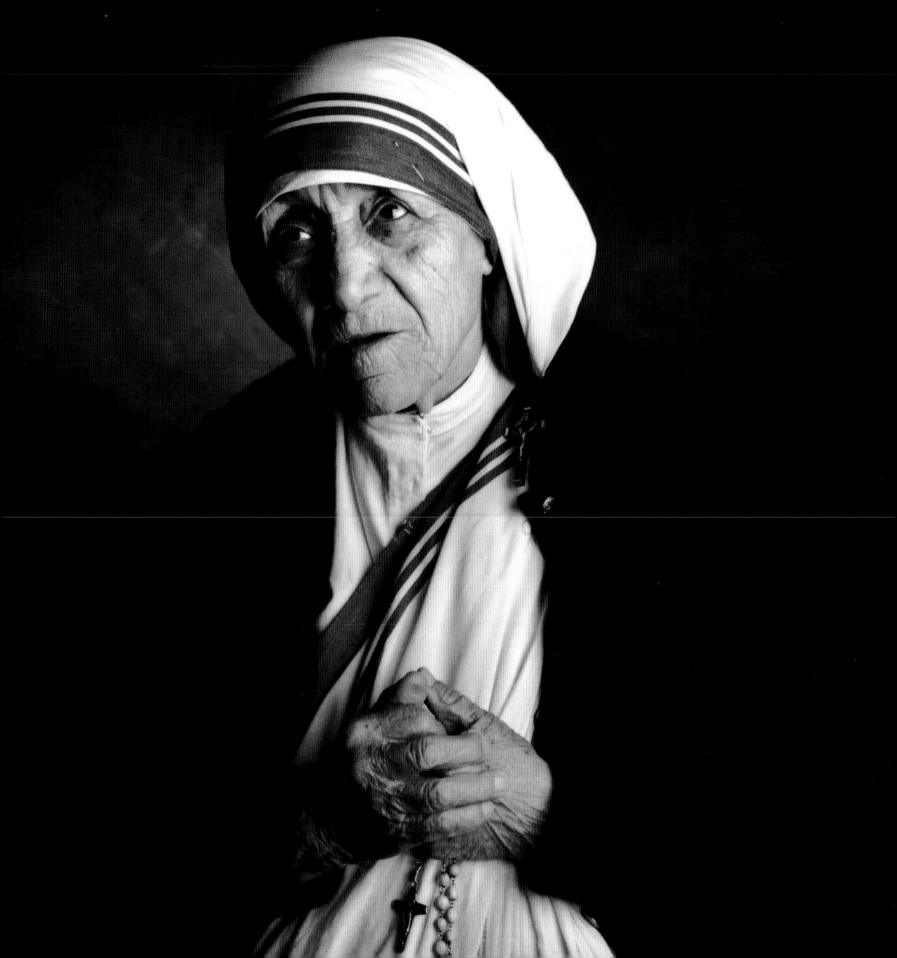

martha graham

by ALMA GUILLERMOPRIETO

FROM TIME TO TIME, she would interrupt the intermediate-level dance class I used to take at her school on East 63rd Street. We would hear the door creak, whichever of her dancers was teaching that evening would stop dead in the middle of demonstrating a phrase and we, the students, would turn around to stare at the advancing monster—the scarlet mouth, the rolling, mascaraed eyes, the lacquered chopsticks plunged into her tied-up hair, the listing, weaving walk as she made her way toward the front of the big, old mirrored studio. If the class was just beginning, we would still be doing the floor work, contracting and spiraling our bodies from various sitting positions on the bare wood floor. Softly, the teacher would command us to stand, but we would already be scrambling to our feet, and as Martha wove through our ranks she would snarl, and pinch and slap us, evidently enraged by our sloppy posture, our dishevelment, our general lack of presence....

That spring—it was 1965—the Martha Graham company presented a three-week season at the Mark Hellinger Theater. Martha was to keep on dancing for a few more years, but it is best not to remember those performances.... [T]here was also the company she created, which that year, it seems to me, danced at a peak of strength and drive and speed, brilliantly demonstrating her genius for connecting emotion with movement. Then there was the body of work she articulated with the vocabulary she had invented—the passion plays with anguished, epic women at their centers: Joan of Arc in *Seraphic Dialogue*, Medea in *Cave of the Heart*.

Above all, there was the evening-length *Clytemnestra*. Those of us who were poor and not talented enough as dancers to merit free tickets—handed out by Martha's sister Geordie—scrimped for standing-room tickets every night that the work was performed. We were young, but I think that we completely understood the seriousness of the commitment Martha Graham made in *Clytemnestra* to the total possibilities of theater, and to a recreation of the moral dimensions—the *grandeur*—of Greek tragedy. We responded, in turn, as if the performance were a task shared jointly between us and the doomed characters on the stage....

I am writing from memory about things I saw 30 years ago and could not possibly forget. After Agamemnon's murder, Helen of Troy, absently beautiful, as it was her fate to be, appeared downstage left and walked distractedly upstage right. Clytemnestra, her sister, appeared on the opposite diagonal, tottering in blood-drunk glee toward the left wing. The two women's paths crossed. Martha—Clytemnestra—trembling with mirth and hatred, flashed a blood-stained knife at Helen. It was Martha imagining the unspeakable. It was Martha—unspeakable, awful Martha—using two figures on an empty stage to rekindle a fury that first saw flames at the start of time. We left the theater filled with terror. She was the last tragedienne.

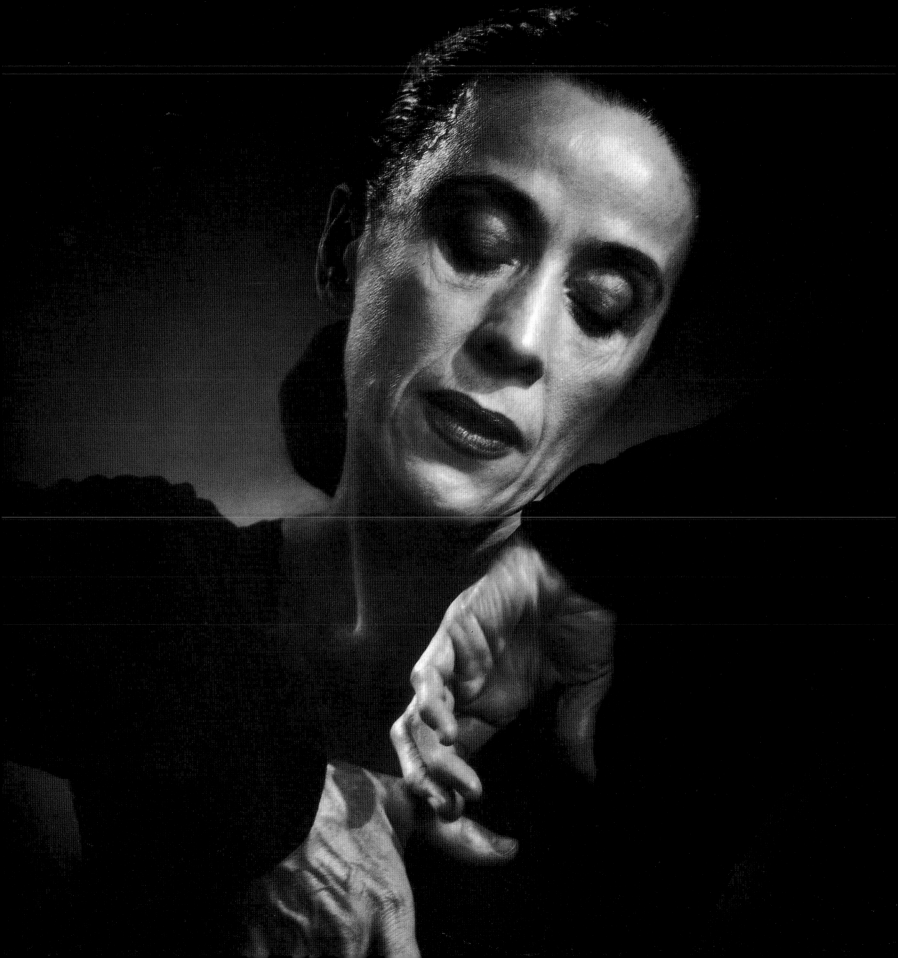

colette

by YVONNE MITCHELL

SIDONIE-GABRIELLE COLETTE was born in 1873 in a small village in Burgundy. She went to Paris at the age of twenty, where she unwillingly, but obediently, started her career as a writer at the instigation of her first husband.

Her books shocked the French bourgeoisie and, indeed, most of the critics; inspired thousands of adolescent boys and girls to write to her, identifying their thoughts and feelings with those of her characters; started a cult; and at the same time gained for her amongst other literary honors, the nomination of Chevalier of the Légion d'honneur on the same day as Marcel Proust.

For those who have never read her but know her name, she is vaguely associated with loose morals, with dancing in the nude in music-hall, with lesbian and homosexual circles, with divorce and lapsed Catholicism. In fact she was instinctively deeply moral, and although perhaps the most truly liberated woman of this century, she not only had no desire to shock but no wish to change anyone to her way of thinking or being. She lived through her five senses. She wrote of the earth with the sure touch of a biologist, of childhood with an impeccable sense-memory, of love with the instinct of a sensual woman. Though the quality of her writing was never in doubt, her choice of characters and milieu were thought by some of her contemporaries to be depraved. In *Chéri,* the love between a spoilt, irresponsible boy of eighteen and his aging cocotte mistress was judged to be offensive, as was the love between a married woman and her husband's mistress in *Claudine en ménage.*

Colette herself had no belief in hierarchy, whether in love, society, or on the "tree of life." She rated the life force pulsating anywhere, in a plant or an insect, as interesting and as worthy of her absorbed attention as the men she fell in love with or the child she bore; and she felt the love between two women or two men, or between a mother and child to be as worthy as the love between a man and a woman.

This one-time *enfant terrible* was acknowledged long before she died, just as she is today, to be among the great writers of modern times.

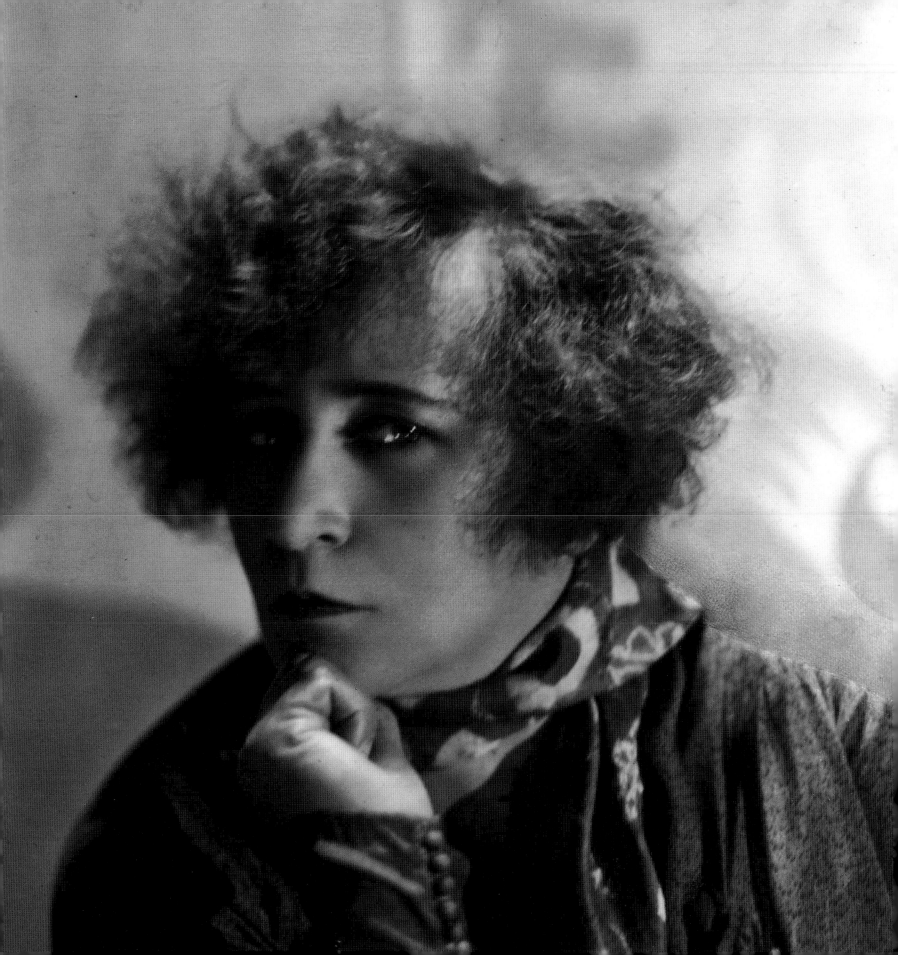

lucille ball

by LINDA MARTIN

I *LOVE LUCY* was more than just the name of a television program. It was a sentiment felt by the millions of viewers who had tuned into the program over the thirty years it has been aired as both an original and as a rerun series. Lucille Ball's comic talent enraptured audiences the world over, and brought her unqualified praise from critics and overwhelming respect from fellow performers. But it had been a long struggle to the top. Ball was forty years old when *I Love Lucy* premiered....

Her manager, Don Sharpe, described Lucy's style as "close to the Chaplin school of comedy—she's got warmth and sympathy, and people believe in her, even while they're laughing at her."

If the critics like Lucy, audiences adored her. At the start of its second season, *I Love Lucy* was the biggest hit in television history. It was estimated that 11,055,000 American families were tuned in weekly, making the program the first TV show to be seen in over ten million homes, an even more impressive figure when one took into account the fact that only fifteen million sets in total were in operation.

There were Lucy dolls, songs, aprons, and furniture. In 1952 when Adlai Stevenson interrupted the show with a five-minute campaign message, his office was inundated with hate mail.

During the original run of the series it never ranked lower than third in the ratings and was often first. Lucy won an Emmy in 1952 and 1955 (as well as in 1966 and 1967 for her later TV series). In 1952 the Academy of Television Arts and Sciences honored Ball as Comedienne of the Year.

Lucy's show was important in terms of female comedy. While it's true that she played the scatterbrained housewife, her program's themes, like her red hair, were a transition between the sexy dumb blonde and the witty independent brunette. Lucy was a housewife to be sure. But what kind of housewife was she?

Lucy Ricardo was not content to stay at home. She wanted to be in show business. Ricky preferred her to be a housewife. Lucy Ricardo did not take orders from her husband. She wanted her own way. As a result the couple were almost constantly quarreling. As in all comedies, programs were happily resolved at the end of each show, but conflict between husbands and wives was often the focal point of the plot. Lucy Ricardo was a far cry from the meek wives appearing in shows like *Father Knows Best* or *Leave it to Beaver*.

It may be easy to measure Lucy's wealth in dollars but her real legacy was the *I Love Lucy* program, where her wonderful talent as a comedian was showcased. Lucy did not believe in entertainment as propaganda. She had no "message." Her main purpose she said was to provide "hope, faith, and fun." With *I Love Lucy* still being rerun on television thirty years after its premiere, her purpose has certainly been fulfilled.

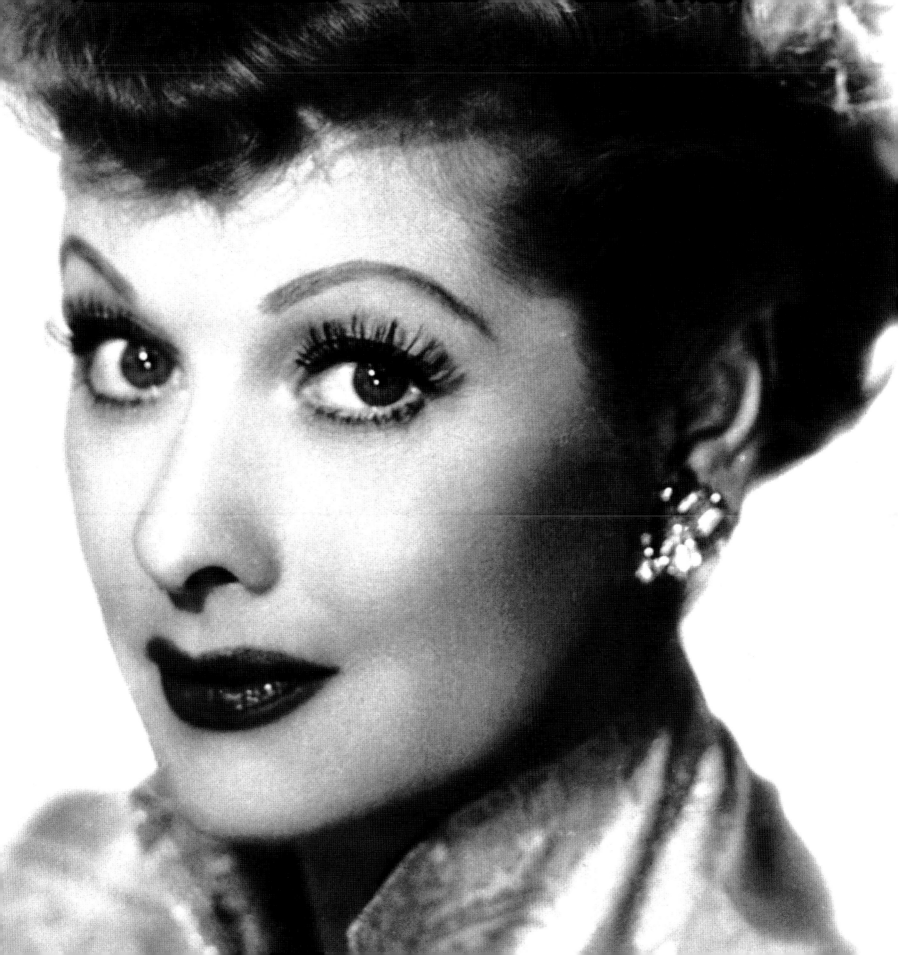

josephine baker

by MEG COHEN

I N 1925 *LA REVUE NÈGRE* opened in Paris to a sold-out theater, making Josephine Baker an overnight sensation and the most popular black entertainer in France. "It is necessary to say she arrived exactly at the moment we needed her," wrote the French theater critic Jean Prasteau. "With her short hair, her free body, her colored skin, and her American accent, she united the tendencies, tastes, and aspirations of that *épôque.*" Credited with bringing the Charleston to Paris and making nudity acceptable evening attire, Baker bid farewell to her humble St. Louis upbringing and, at 19, began a love affair with France that would continue until her death in 1975.

Parisian life suited Baker. Even when her act traveled across Europe and around the world, she always returned to "my country," as she called it. "I loved everything about the city," she once said. "It moved me as profoundly as a man moves a woman." She loved the freedom, the clothes, the nightlife—the men. Baker's reputation as a lover was unsurpassed: during a show's run at a casino, she and a stage manager used to have sex in the wings between acts. Although she married several times, she never seemed able to satisfy her voracious sexual appetite.

But her love of men was almost matched by her love of animals. Baker traveled with an eclectic menagerie—monkeys, birds, rabbits, snakes, turkeys, even a cheetah (she used to walk him in the mornings on the Champs-Élysées). On one occasion she had to obtain passports for her dogs to cross the Swedish border.

For all her eccentricities and unconventionalities, Josephine Baker was a professional. And there was more to her than her public persona. Fighting for civil rights, she spoke out against segregation. She donated to charities and did intelligence work during World War II. And she adopted a "rainbow tribe" of children from around the world. Jean-Claude Baker, included in Josephine's brood, has written the biography *Josephine: The Hungry Heart,* with Chris Chase. In it the author notes: "[George Balanchine] said, 'She is like Salome. She has seven veils. If you lift one, there is a second, and what you discover is even more mysterious.... Only at the end, if you keep looking faithfully, will you find the true Josephine.'"

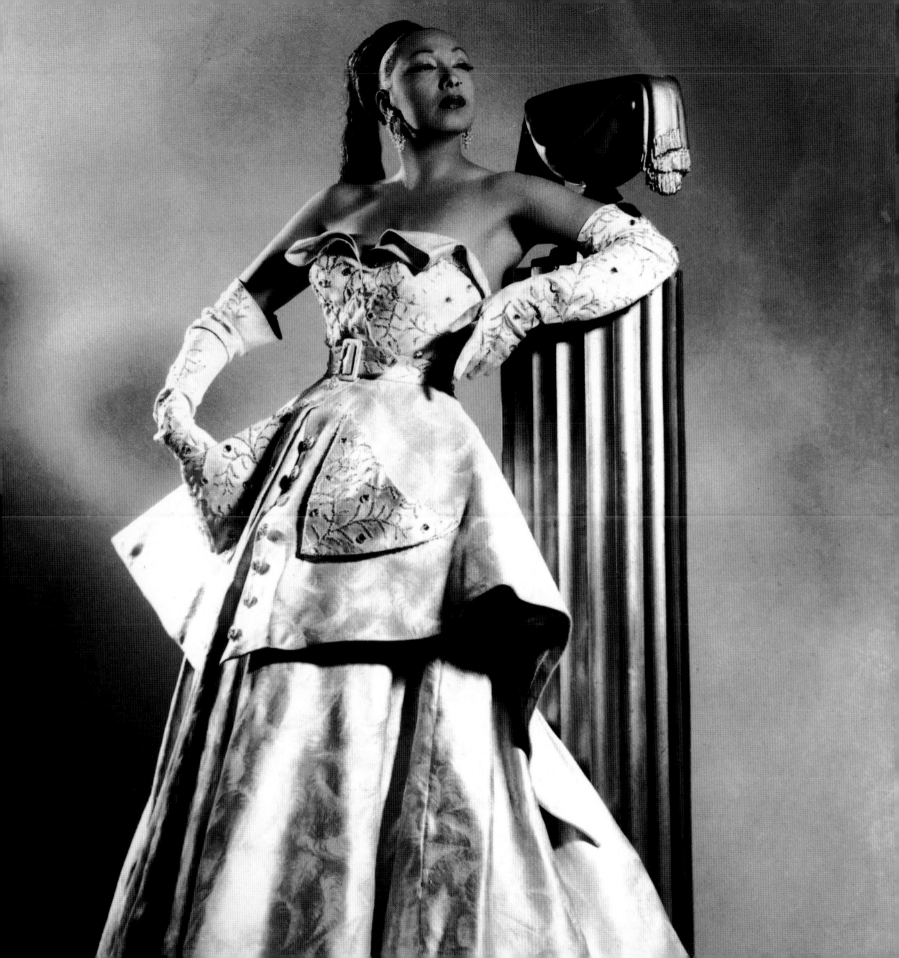

lynn margulis

by ELIZABETH ROYTE

EARLY ONE MORNING, Lynn Margulis squeezes between rows of plants in the university's greenhouse. From a cycad, a tall, long-leafed plant, she collects a root that she'll inspect under the microscope. She stops to poke at what appears to be a layer of dried slime in a tray. This slime is Margulis's white rat, a microbial mat from Baja California. The layers of microbes are continually eating, breathing, having sex, fermenting, and releasing gases into the atmosphere—an ecology that Margulis understands intimately.

It was Margulis's expertise in the metabolism of microbes that led her, in the mid-70s, to the British atmospheric chemist James E. Lovelock. After measuring atmospheric gases for years, Lovelock suspected that living organisms had a greater effect on the atmosphere than was recognized. Margulis concurred. Before the evolution of plants and animals, bacteria and larger microbes dominated the earth, each interacting with the atmosphere's gases. Lovelock and Margulis proposed that the earth's biota still runs the show, regulating the terrestrial and atmospheric conditions that make the planet habitable—neither too hot nor too cold, the oceans neither too salty nor too acidic. The chance of all this happening coincidentally, Lovelock believed, was just about nil. He decided to call their hypothesis Gaia, for the ancient Greek goddess of the Earth.

From Day 1, the world's response to the Gaia hypothesis, as presented in its developers' papers, was mixed. Lovelock's personification of the earth attracted new-agers and goddess worshippers. But this was not the company Margulis wanted to keep, and she warned Lovelock against deifying Mother Earth....

An outspoken advocate of population control and biodiversity, Margulis nonetheless insists that Gaia *can* take care of herself. "Gaia is a tough bitch," she says. "People think the earth is going to die and they have to save it. That's ridiculous. If you rid the earth of flowering plants, people would die, period. But the earth was without flowering plants for almost all of its history. There's no doubt that Gaia can compensate for our output of greenhouse gases, but the environment that's left will not be happy for any people." It will, however, be happy for microbes....

Margulis has said that the only way behavior in science changes is when "certain people die and differently behaving people take their place." She has a point: Alfred Wegener's theory of continental drift wasn't accepted until after his death, when plate tectonics were discovered. The same may happen with the Gaia hypothesis, her debunking of neo-Darwinism, and her spirochete theory.

"I haven't convinced everybody, and I know it will be a while," she says with insouciance. "There will be tweakings, certain modifications as we learn more, but it doesn't matter what anyone else thinks. I know it's right."

frida kahlo

by GUADALUPE RIVERA

I ARRIVED IN COYOACÁN in August 1942—Diego's teenage daughter by his first wife, Lupe—with little luggage. I found Frida in the kitchen. As usual, her outfit took me by surprise. She wore a black *huipil* with red and yellow embroidery and a soft cotton skirt in a floral print that seemed to come alive when she moved....

The morning of my arrival in Coyoacán, Frida had just gotten back from Melchor Ocampo market, which was quite near the Blue House. She had gone with Chucho, one of those hired hands no respectable village family can do without. *La niña Fridita* ("little Frida"), as her cook Eulalia affectionately called her, was unpacking fruit and vegetables from a large basket. At one point she said to me: "Look at this watermelon, Piquitos! It's an amazing fruit. On the outside, it's a wonderful green color, but on the inside, there's this strong and elegant red and white. Fruits are like flowers: they speak to us in a provocative language and teach us things that are hidden." ...

I followed her into the dining room and tried to help her set the table, although I was so astonished by what I saw that I could scarcely do a thing. For Frida, setting the table was a ritual, whether she was unfolding the white openwork tablecloth from Aguascalientes, or arranging the simple plates that she had customized with her initials, or setting out Spanish Talavera plates and handblown blue glasses and heirloom silverware.

A few moments later came the act of placing the flower vase in the center of the table. Into the vase went a bouquet that Frida had cut in the garden. It mimicked the flowers she wore in her hair, mimosa and marguerites of different sizes mixed in with little red-and-white roses. Frida grew the plants and flowers herself. She went to the gardens every day to see how they'd grown and were blooming.

In a friendly, slightly ironic voice she asked me to follow her to her studio. She was perfectly aware that I felt out of place. We picked up the basket of fruit, and after her I went. As soon as we entered the studio, I was in the grip of an even greater amazement. A group of her paintings hung on the walls, *The Two Fridas* occupying the place of honor. The painting's strange combination of suffering and fear quite overwhelmed me. Breaking the silence, Frida remarked, "Now that I have fruits like these, Piquitos, and a little owl that lives in the garden, I'll be able to paint again some day!" True to her word, in 1943 she painted *The Bride Frightened at Seeing Life Opened*.

In this work the freshness of a watermelon, the seedy core of a papaya, and a little owl's staring eyes speak to us of that openness and liveliness of spirit that Frida lost in the last years of her life.

She also painted a doll from her collection, the one that was dressed as a bride. She must have wanted to recapture the expression of a young woman astonished by the spectacle of life, which was something that she herself had lost at an early age, years before she wore her own wedding gown.

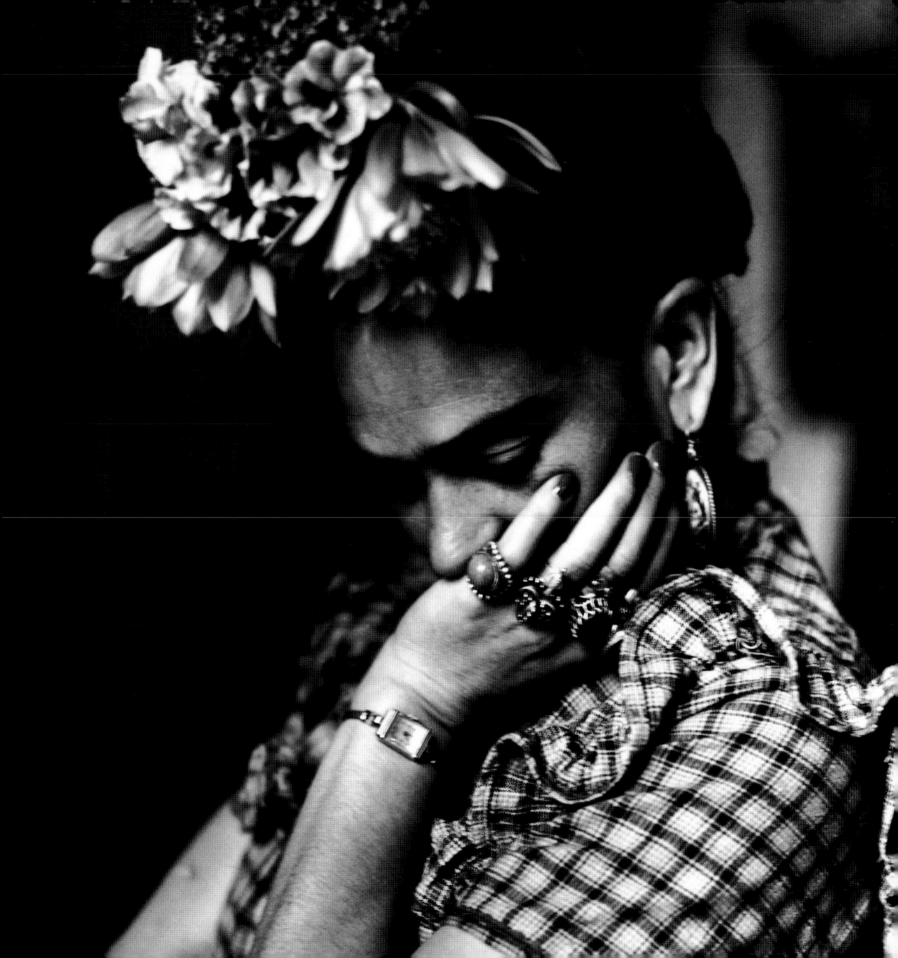

bette davis

by JANET FLANNER

S O FAR AS SHE has been permitted, Bette Davis has molded her film career on her motto, "I love tragedy." Until Pearl Harbor she was the American favorite of the Japanese moviegoers because, they said, she represented the admirable principle of sad self-sacrifice. An adult-minded New Englander, atavistically suspicious of happy endings, she was so convinced by her early Hollywood parts that a floppy feminine hat was a symbol of celluloid sappiness that she later had written into her contract a clause permitting her to refuse to carry a hat in her hand like a damned basket of rosebuds.

Becoming a big star often addles a human being, usually in one of three ways; the victim becomes a superior, lonely ego and stays home, or becomes a public character and goes out constantly, or becomes glamorous, no matter where he or she happens to be. Miss Davis was glamorous, years ago, for about a month. This period ended when, backed up by a smart town car containing a white poodle and liveried chauffeur, and attired in moody black velvet slacks and jacket, she met her mother, who had been on a trip East, at the Los Angeles railway station. Mrs. Davis was unable to believe her own eyes and flatly said so. The glamour was dropped later that day.

It is her notably large eyes, disliked at first by both Hollywood and herself, which finally accelerated her ascent in pictures. When Hollywood at last got around to making analyses, it discovered that eighty percent of screen acting is concentrated in the eyes. In *Dark Victory* Miss Davis made it one hundred percent. Since her rôle was that of a woman threatened with insanity, her director wanted her to indicate her disorder by crazed motions of the hands. She decided to use only her eyes. Even the quantity of her erotic appeal, which so worried the studios at the beginning, has been recomputed. When a producer said she had no more sex appeal than Slim Summerville, she said he went too far. Now producers go even farther; they say she is solid, ice-cold, Puritan sex, of the type against which the Sunday blue laws had to be passed.

If you asked the Hollywood trade who is the best actress in the business, the unanimous, indeed the only fashionable, answer was Davis. The trade adds, *sotto voce,* that her box-office was enormous because men fans are convinced that she was feminine, though she was really only maternal.... This in turn alarmed her. Some metropolitan theatre critics claim that she seemed complex in her rôles because she herself was an unresolved character. On the other hand, émigrés from Europe felt that she should have been the dominant member of a great national stock company, like France's Comédie-Française, rather than be allowed to beat out her talent and wings in the movies.... She probably always thought of the stage when she thought of a good play, and to her the cinema undoubtedly remained something done with improved lantern slides. "A movie," she once said, "is not even a dress rehearsal."

jacqueline onassis

by MARILYN JOHNSON

FROM A DISTANCE she seemed like someone who could take us or leave us. She would smile and shake hands as we streamed past a reception line, but she didn't seem to need us, not the way politicians and celebrities usually need people.

If someone approached her on the streets of New York to say *I admire you so much,* she would smile. She'd say nothing. She rarely spoke to us.

If she wanted to befriend us, we would know it. She was forthright, funny, and fiercely loyal. But with most of us she kept her distance....

She didn't need us. She was in politics incidentally. She could have done without its sweat and insincerity. She was a would-be expatriate to stage, and we were her audience. When she finally turned her attention to us, she was charming. The White House was our house, too, she said graciously as she invited us in. She had such enthusiasm for its beauty and detail, and such a majestic vision of its possibilities. This was her gift throughout her life, salvaging things that were crumbling or threatened—Grand Central Terminal and the ancient temples of Egypt, the White House and the reputation of her husband—and turning them into Camelot.

"Before everything slips away," as she said, "before every link with the past is gone," she saved some of it for us.

She was so composed. As a little girl, she had seen her parents lose their temper and their self-control with terrifying frequency: and so she learned how to stay within herself. Only once did she crack, in the confusion of gunfire, crawling across the trunk of a moving car. Within minutes she managed to reel herself in and find the strength to face the destruction of her husband.

She knew exactly what to do. It was eerie, almost as if she was destined to command us through such a crisis. She bore witness in her bloody pink suit to an orderly transition of government, then set to work finding out with what ceremony Abraham Lincoln had been buried. When the time came, she covered her face with a black veil and made the long walk behind a riderless horse. That terrible procession, drumrolls punctuating the silence, Bobby on one side of her, Teddy on the other. That moment when, clutching the hands of her two children, she deemed it was time for her son to salute. And all of us, with our need and longing, following her into history.

She didn't say a word.

Soon after, she put on her dark glasses, walked offstage into her private life, and politely but firmly put an end to our expectations.

She left us years before she died.

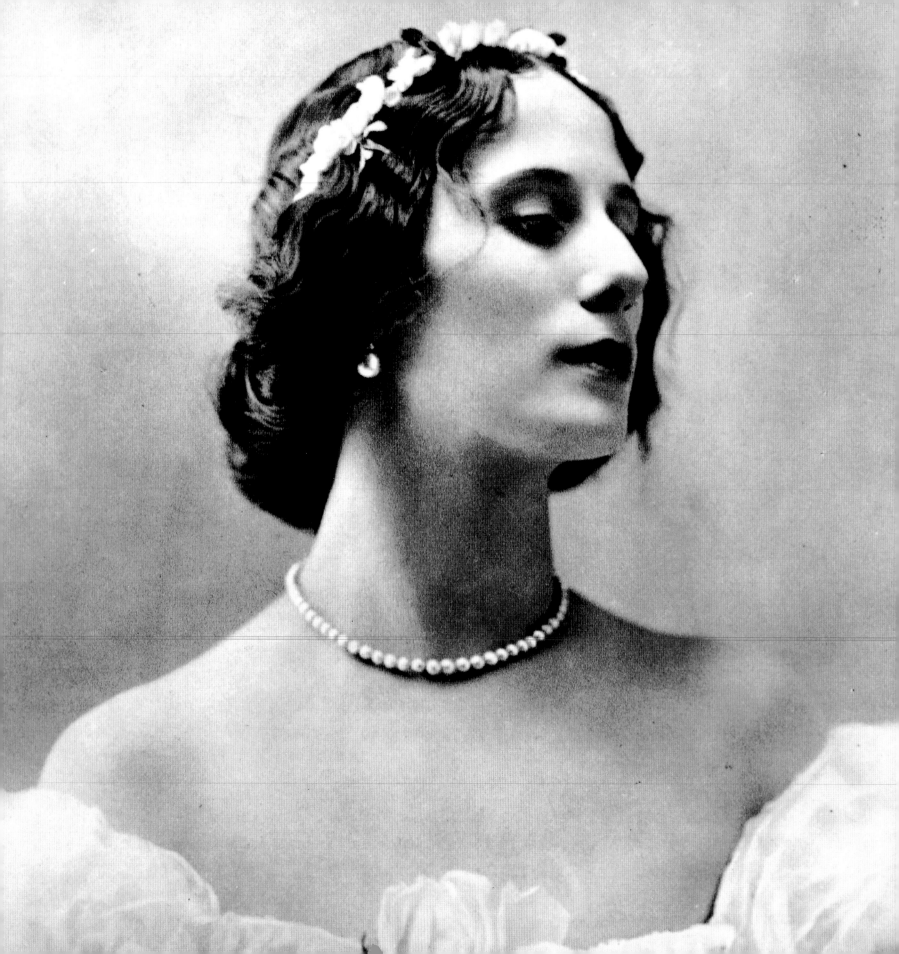

anna pavlova

by ALLEGRA KENT

ONE OF THE FIRST BIOGRAPHIES I ever read was about Anna Pavlova. When I was 11, I took it out of the library, just before seriously beginning my own study of ballet. Even the name of this woman born half a world away had an enchanted quality to it: the two *v*'s were winged water birds, and the word "love"—slightly in disguise, altered by an *a*—also made an appearance. Her story gripped me, of course. The legendary prima ballerina was born in St. Petersburg in 1881 during the cold whiteness of a Russian winter. When she was 8, her mother took her to a performance of *The Sleeping Beauty*, and Anna experienced an epiphany—a baptism by ballet. This and only this was what she wanted to do with her life, and two years later she was admitted to the Imperial School of Ballet. Her exceptional gifts were immediately visible, and after graduating, at 18, she made her company debut in a pas de trois in *La Fille Mal Gardée*; she never danced in the corps de ballet.

Pavlova was already an acclaimed ballerina when, in 1905, Michel Fokine choreographed *The Dying Swan* for her to music by Saint-Saëns; it became her personal emblem. In fact, a woman imitating a swan is an absurd idea. The body parts don't match, and the bird is graceful only when swimming. A swan's foot is a webbed black affair that the bird can shake out like an old dishrag before folding it neatly under a wing. Pavlova en pointe and in motion had no duckish quality whatsoever. *The Dying Swan* is not about a woman impersonating a bird, it's about the fragility of life—all life—and the passion with which we hold on to it. Pavlova's sheer dramatic intensity forcibly conveyed this truth to the audience, and the work was an instant success. . . .

During World War I, Pavlova performed throughout North and South America, dancing night after night, appearing in many pieces on every program and of course giving her all always: the audience had come to see her alone. Eventually her travels took her to Japan, India, virtually everywhere. . . . After a grueling English tour in 1930, Pavlova, now nearing 50, took a three-week vacation at Christmas. On her way back to work in The Hague, there was an accident, and, wearing only a light coat over silk pajamas, she walked the length of the train through the snow to see what had happened. Days later double pneumonia set in. The swan was alone on the lake. The woman who could portray death and transfiguration on the stage was fighting for her life. Her condition deteriorated rapidly. Dying, she asked that her swan costume be brought to her. She looked at it longingly. Only death could separate her from dance.

Anna Pavlova continues to dance for us through her photographs: they evoke a moment in flight, and our imagination recreates the rest. We can only glimpse the exquisite whole—her entrances and exits and the cascading flowers that fell to her feet during the bows. When F. Scott Fitzgerald had one of his characters say "Anna Pavlova's a hoofer, isn't she?" it was with evident ironic implication. Everyone knew she was the greatest dancer of her age.

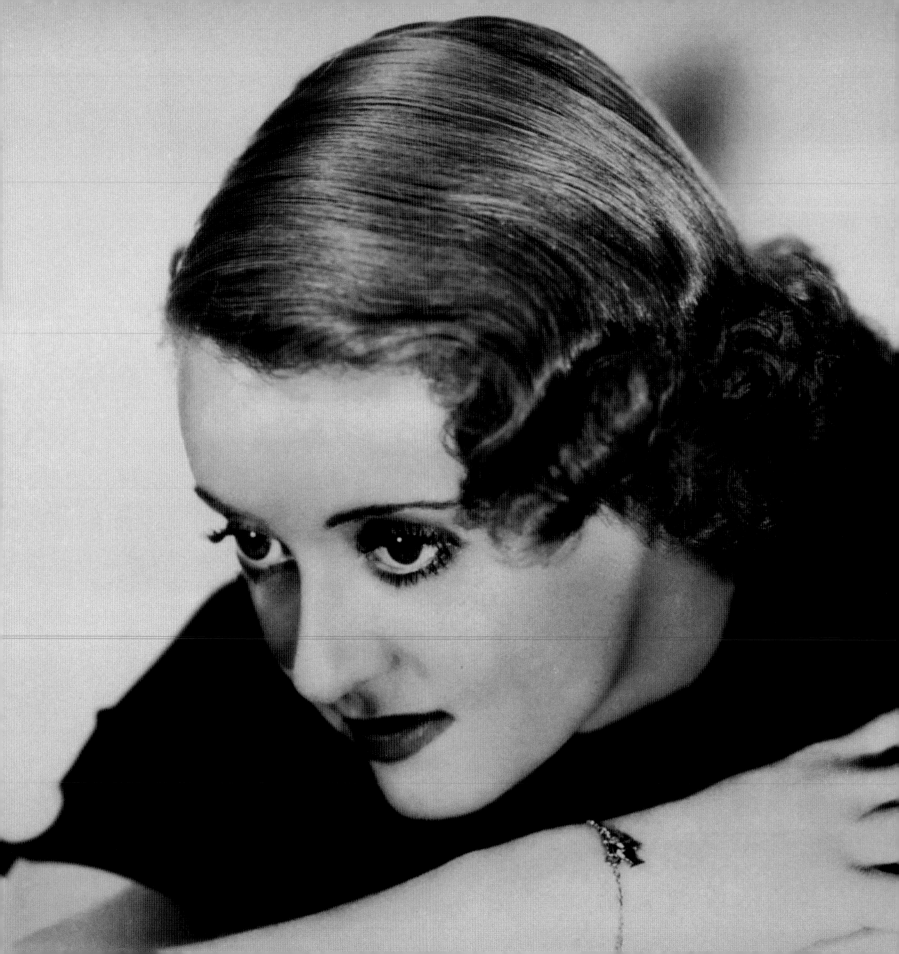

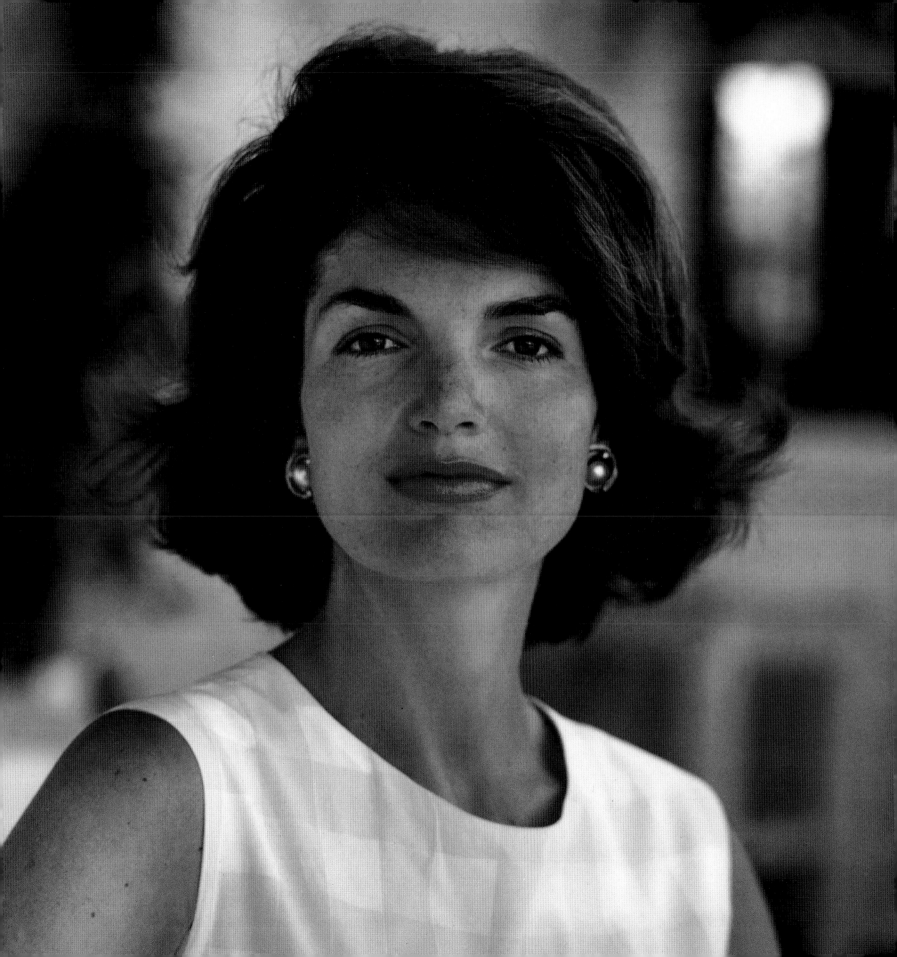

ella fitzgerald

by MARGO JEFFERSON

EVER SINCE I FOUND OUT about the horrors of Ella Fitzgerald's youth, I've wanted to protect her from the scrutiny of critics and fans like myself, who have always inflected the pleasure we took in her singing with patronization.... That voice never did give us intimations of the stepfather who abused her when her mother was dead; of the aunt who rescued her, then had no time or money to care for her; of Ella herself as a teen-age truant who did time in a New York State reformatory for girls, where discipline was instilled through beatings and solitary confinement. When she ran away she went from wayward girl to urchin, shuffling alone through the streets of Harlem, singing and dancing for small change, sleeping wherever she could find a night's bed and board.

It was this grimy little urchin who got herself onto the stages of the Apollo Theater and the Harlem Opera House, won their amateur singing contests, then almost stumbled back into oblivion because she lacked glamour or sex appeal....

Thank God for the radio and the phonograph: they gave a singer like Ella Fitzgerald the same advantage—invisibility—that letters gave Cyrano de Bergerac. And thank God for jazz. It gave black women what film and theater gave white women: a well-lighted space where they could play with roles and styles, conduct esthetic experiments, and win money and praise. Ella Fitzgerald had a voice any romantic-comedy heroine would kill for: can you imagine her trying to fit her persona into one of those bossy, sassy or doggedly stoic movie maid's roles patented for hefty women of color? Can you see her in *Imitation of Life* or *I'm No Angel*; in *Alice Adams* or *Gone With the Wind*? ...

By the 1960s she was singing wonderful songs. But she was never a dramatist. She doesn't really interpret songs; she distills them. She gives us pure gaiety and clarity. Pure rue and longing too: listen to her sing Gershwin ballads, especially accompanied by Ellis Larkins; listen to her sing "You Turned the Tables on Me," "Something to Live For," "Can't We Be Friends?" or "Angel Eyes," especially that wistful final line: "Excuse me while I disappear."

Sadness is an emotion recollected in tranquillity. Despair is absent from her work and (so it seems) from the life: how else could she have invented herself, then sustained the invention for so long? There was a core of fierceness, though, which her invincible musicality let her deploy with cunning. Popular music is one endless love song that, I suspect, the basically solitary Ella Fitzgerald approached much as the basically solitary Marianne Moore approached poetry: reading it with a certain contempt for it, Moore said, you could find a place in it for the genuine. Think of contempt as a self-protective code word here: we are talking about the refusal to write or sing in any voice but the one you know to be your own.

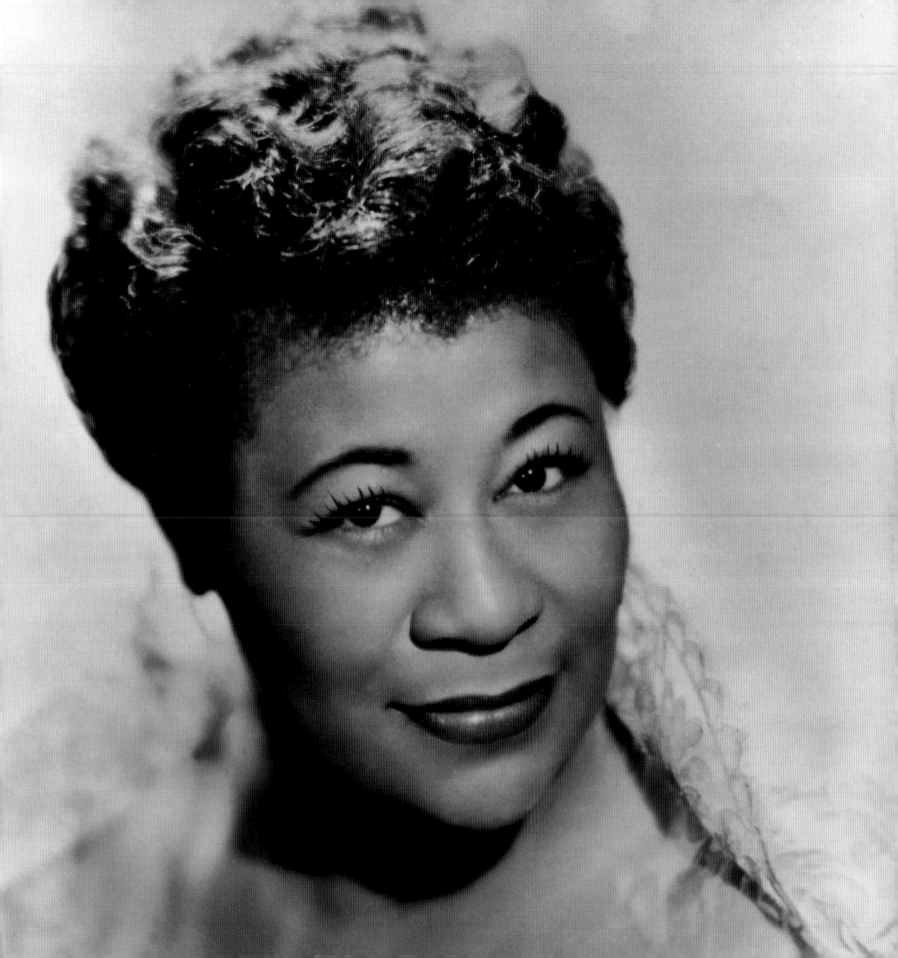

gertrude stein

by CYNTHIA OZICK

SHE BECAME THE GODDESS of her age; she became the incarnation of that age; she became its legend; she became its symbol. "I have been the creative literary mind of the century," she announced. And another time: "Think of the Bible and Homer, think of Shakespeare and think of me." But we do not remember Gertrude Stein for saying any of these outrageous things. As a writer she is defined for us by only four quotations—egoless catch phrases, her logo and trademark: "Pigeons on the grass alas." "A rose is a rose is a rose is a rose." (Four roses; heavier brew than the three commonly cited.) To Ernest Hemingway, after World War I: "You're all a lost generation." On her deathbed: "What is the question?"

She intended to seize and personify modernism itself, and she succeeded. Consequently, we cannot imagine Gertrude Stein without Picasso. Like him, she wanted to invent Cubism—not in oils but in words. She worked to subtract plain meaning from English prose. Whether she was a charlatan or a philosopher, it is even now hard to say. William James, with whom she studied psychology at Radcliffe, sent her on to Johns Hopkins to do research on automatic writing.... Certainly there appears to be more than a little of the subconscious in many of her sentences, but mainly they are mindful, calculated, striven after, arranged. "Think well of the difference between thinking with what they are thinking"—is this nonsense, or is it an idea too gossamer to capture? She was deliberately, extravagantly, ferociously extreme, and as concentrated and imperial as Picasso himself, who painted Stein just the way her companion Alice B. Toklas described her: a woman with the head of a Roman emperor....

The visitors who passed through the bohemian dazzle of her Paris apartment were nearly all illustrious. Hemingway said that he and Stein were "just like brothers." Juan Gris, Sherwood Anderson, Clive Bell, Wyndham Lewis, Carl Van Vechten, Ezra Pound, Ford Madox Ford, André Gide, John Reed, Paul Robeson, and the geniuses on her walls, Picasso and Matisse—all these paraded past her witty tongue, while squat Alice Toklas looked loyally on. During the German occupation of Paris, when Jews were being hunted by the thousands, these two Jewish woman fled to obscurity in the countryside; their Montparnasse flat, with its paintings, was left unmolested. And when Gertrude Stein died in 1946, at 72, her name was a household word (or quip), her mannish head an avant-garde image, and she had become one with the movement she touted.

At the close of its century of brilliance and triumph, modernism begins now to look a little old-fashioned, even a bit stale or exhausted, and certainly conventional—but what is fresher, and sassier, and more enchantingly silly than "A rose is a rose is a rose..."? This endearing, enduring, durable, and desirable chant of a copycat Cubist is almost all that is left of Gertrude Stein.

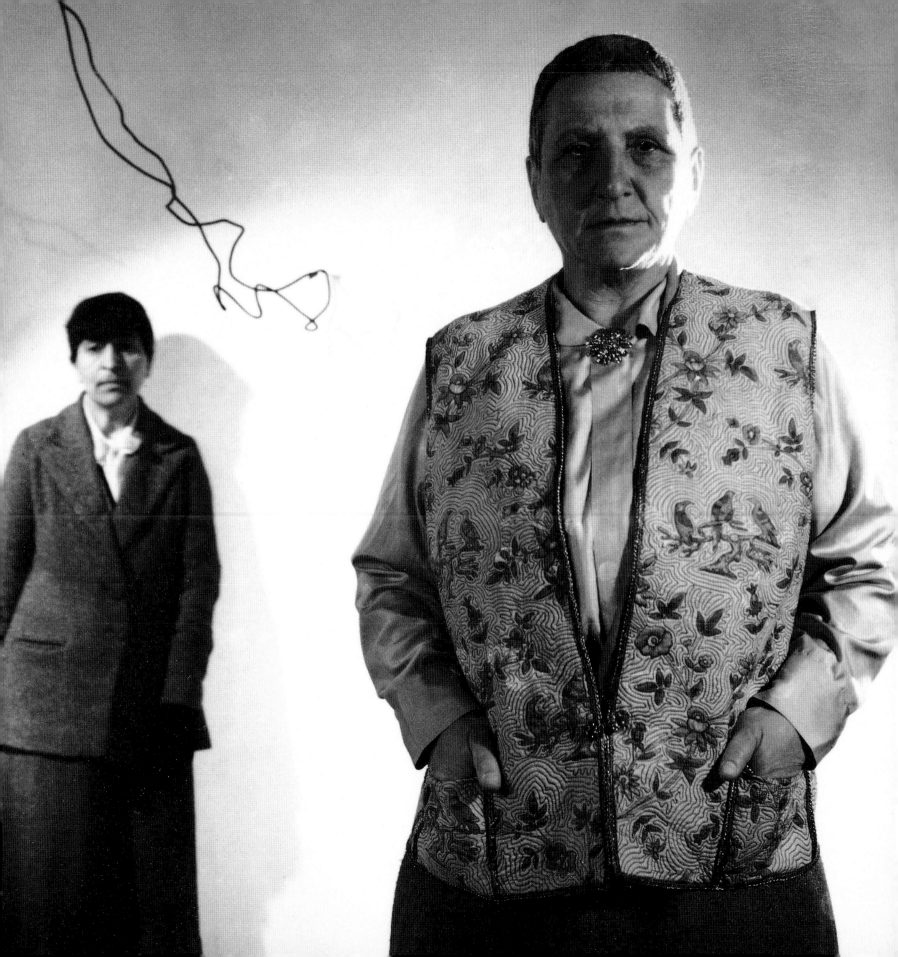

elizabeth taylor

by ANNE HOLLANDER

SHE HAS LATELY STEPPED gracefully down a few notches from her pinnacle, but her image is indelible, and she has earned the right to a certain voluntary eclipse. Now in her middle 60s, an age at which Marlene Dietrich was still appearing nightly in sequins and feathers, mesmerizing live audiences in Las Vegas, Elizabeth Taylor is a select apparition, visible only here and there.

As a child star whose chief charm was striking beauty, not cuteness or wistfulness, Taylor was trained early to glow for the camera, to sustain herself as a perfect image rather than as a particular character. As Helen Burns, the heroine's saintly little schoolfellow in *Jane Eyre*, which she made (along with *National Velvet*) in 1944, when she was 12, she lets her beauty do all the work; it produces the sweetness and saintliness and the pathos of her death all by itself.

She became an un-self-conscious beautiful creature, acting the part in life and on screen. A luscious womanly ripeness, complete before she was 17, was added to the incandescent look she had at 12, and together they gave her an extremely traditional dark feminine beauty, unguarded, pure and strong, devoid of caprice or guile. Her figure was without sinew and apparently boneless in the classical manner.

Taylor could be besotted (*Cleopatra*) or devoted (Rebecca in *Ivanhoe*) or a doomed Southern belle (in *Raintree County*), because she herself seemed to be one of those mythical dark ladies who are all the same Dark Lady, ever since the Bible and ancient Greece: she who stands for imprudently excessive passion, or devotion, or fury, and who eventually loses out; the one who may well die or go mad or be otherwise sacrificed to a man's duty or ambition in favor of the reticent Blonde who will be his ultimate prize.

As the '60s and her 30s were ending, she began to play the part of Fading Beauty, on film and in life; and she became much more interesting to her public. More hysteria and bitterness, more anxiety and desperation came to flavor the perfect face and body, and she began to gain weight. Her life and her roles became more baroque; she lost the weight and gained it back; she had well-publicized medical crises; she began to seem truly human, more like the fleshy brunettes of real life. A tinge of the victim, never absent from her Dark Lady image, was increased and gave zest to public perception of her now-threatened beauty. Leveled at her chin and waistline, her fans' gaze sharpened as they held their breath....

Taylor has appeared on the stage, perhaps to prove she's a real actress; but the theater, where illusion is paramount, is no place for this mythic creature who, in the purest cinematic tradition, has always played herself.

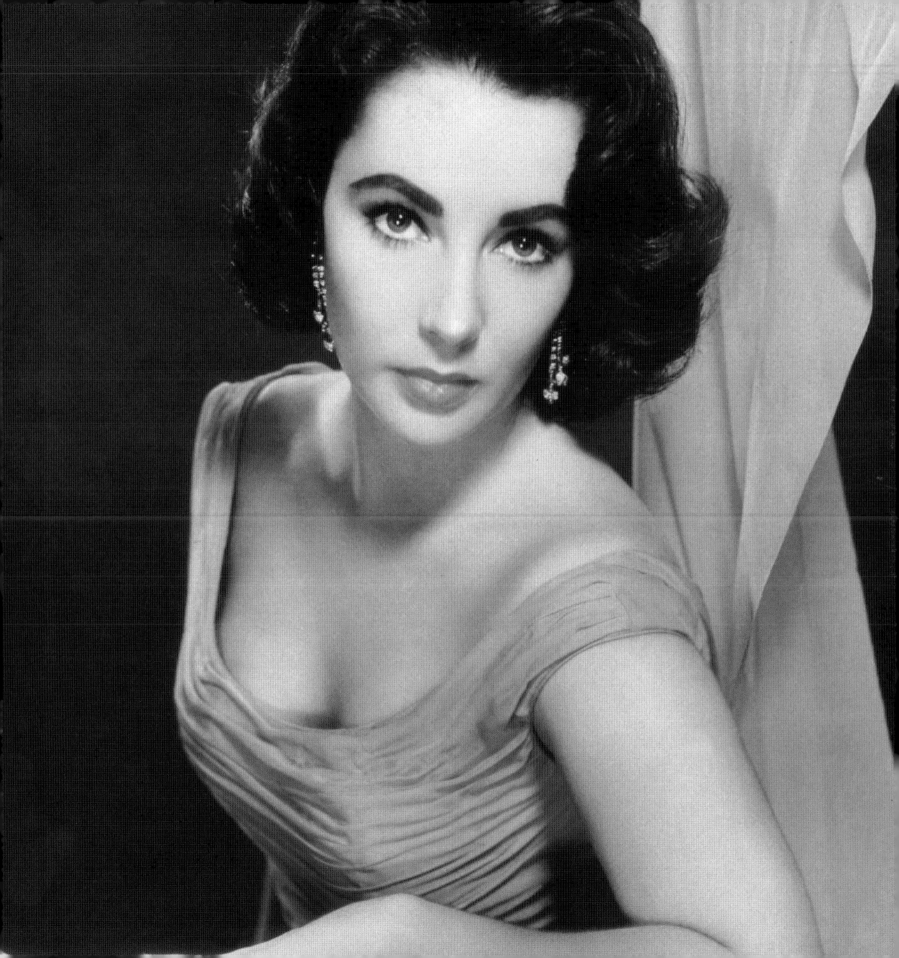

golda meir

by JUDY GITENSTEIN

LIFE IN AMERICA WAS DIFFICULT for poor immigrant families. At eight years of age, Golda had to work every morning in her mother's grocery store, leaving her no choice but to arrive late at school. Later, her mother wanted her to give up high school, work in the store, and marry. But Golda was strong-willed and determined to continue her education. At age fourteen, she ran away to Denver to live with her older sister Sheyna and go to school.

In Denver, Golda continued high school. Zionists, Socialists, and anarchists visited her sister's home and aroused Golda's political interests. She became a Zionist—someone who believes in the right to a Jewish homeland—and joined the Labor Zionist party.... [Taking] a full-time job with the Labor Zionist party, she met and married Morris Meyerson. The couple settled in Palestine....

Her political rise was rapid.... On May 14, 1948, Golda was one of twenty-five signers of Israel's Proclamation of Independence.... In 1956, Israeli Prime Minister David Ben-Gurion named Golda minister of labor. He suggested that his cabinet begin to use their Hebrew names, so Golda Meyerson became Golda Meir, which means "to illuminate."

As Israel's first minister of labor, Meir orchestrated the building of thirty thousand houses and two hundred thousand low-income apartments. As a woman in a formerly all-male cabinet, she brought a new perspective to government. She could be quick with a comeback when she knew that her colleagues were wrong. Once, when the cabinet was discussing curfews for women because of an outbreak of attacks at night, Meir responded, "But it's the men who are attacking the women. If there's a curfew, let the men stay at home, not the women."

Meir became secretary general for the Mapai party and later of the Israel Labor party under Prime Minister Levi Eshkol. When Eshkol died in 1969, the party selected her to serve as prime minister until the next elections were held. As prime minister, Meir sought the support of the United States as well as armaments to build Israel's defense. The weight of the Arab-Israeli conflict rested on her shoulders, and though she always sought peace for Israel, this was not always possible.

In 1973, Syrian and Egyptian forces launched a surprise attack against Israel on Yom Kippur, the holiest of Jewish holy days. Criticized for the country's lack of preparedness for the war—and for the large number of people in the Israeli Army who were killed—Meir had no choice but to turn the reins of government over to Yitzhak Rabin.

Golda Meir, at seventy-six, was not ready to retire, however. She continued to raise money, speak, and meet with world leaders in an effort to reach a peaceful agreement with the Arabs. When she wasn't traveling, she took care of her grandchildren in Jerusalem. She died at age eighty of liver infection and leukemia.

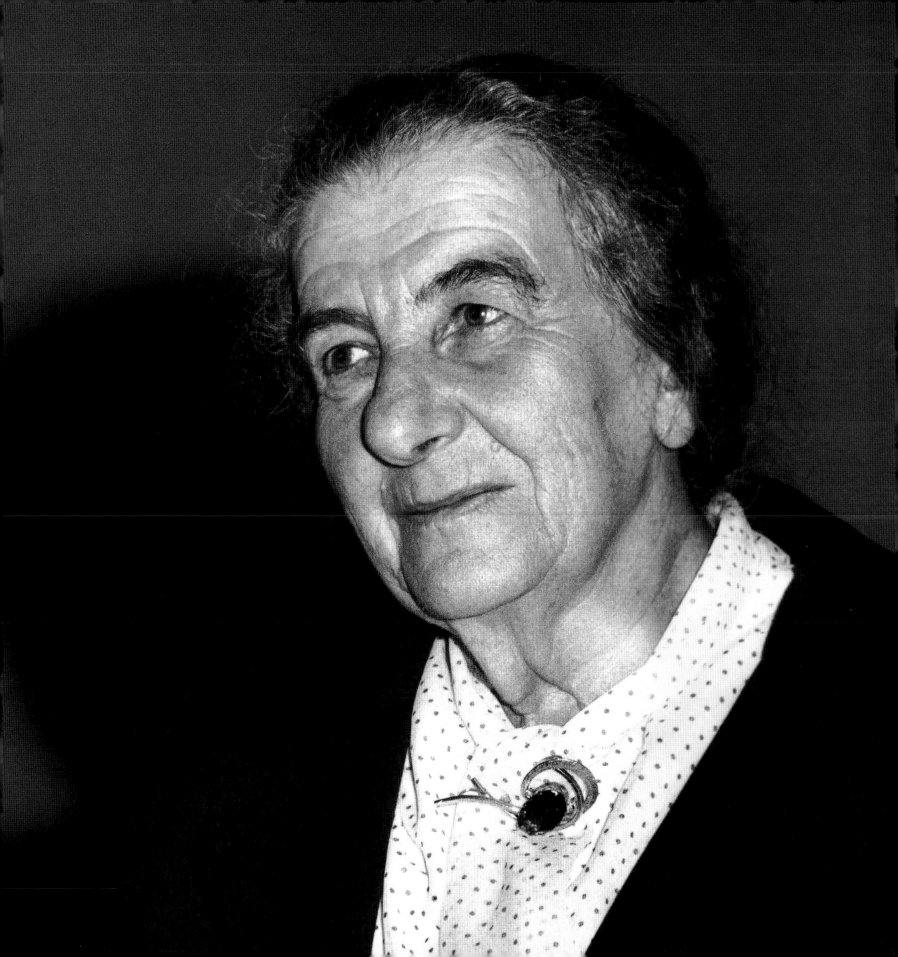

oprah winfrey

by MAYA ANGELOU

SHE WAS BORN POOR and powerless in a land where power is money and money is adored. Born black in a land where might is white and white is adored. Born female in a land where decisions are masculine and masculinity controls. This burdensome luggage would seem to indicate that travel was unlikely, if not downright impossible. Yet, among the red clay hills of Mississippi the small, plain black girl with the funny name decided that she would travel and that she would do so carrying her own baggage.

Today, even in the triumphal atmosphere that surrounds her, the keen observer can hear a shard of steely determination in her voice and catch a look of steady resolution in her amber eyes.

She used faith, fate, and a smile whose whiteness rivals the flag of truce to carry her from the dirt roads of the South to the world's attention. The Creator's blessings, a lively imagination, and a relentless drive have brought Oprah Winfrey from the poignancy of a lonely childhood to the devotion of millions.

One loyal fan has said, " We can thank Oprah for some of the sanity in our country. She is America's most accessible and honest psychiatrist."

Oprah, as talk-show host, tries to manage a calm façade as she lends an ear to brutes, bigots, and bagmen, but her face betrays her. Her eyes will fill with tears when she listens to the lament of mothers mistreated by their offspring, and they dart indignantly at the report of cruelty against children and savagery against the handicapped. The even, full lips spread into a wide, open smile when a guest or audience member reveals a daring spirit and a benevolent wit.

She is everyone's largehearted would-be sister, who goes where the fearful will not tread. She asks our questions, and waits with us for answers.... Oprah's road has been long, and her path has been stony. After her parents separated from each other and from her, she was left in the care of a grandmother who believed in the laying on of hands, in all ways; in prayers, and that God answered prayers. She learned behavior from her grandmother that she continues until today. She kneels nightly to thank God for His protection and generosity, for His guidance and forgiveness. She has a genuine fear of sin and sincerely delights in goodness....

Throughout history, women have picked their ways out of ominous mine fields of danger and forests of contempt. They have carried their teepees on their backs, and worked for ludicrous salaries from California's Asian sweatshops to the steam lofts of New York City's Lower East Side. They have survived the indescribable horrors of slavery and the unspeakable atrocity of the Holocaust. Those who preceded Oprah were yesterday's pathfinders, and today Oprah Winfrey continues her journey paving the way for other young white, black, Hispanic, Asian, and Native American women to follow. She is one of our Roadmakers.

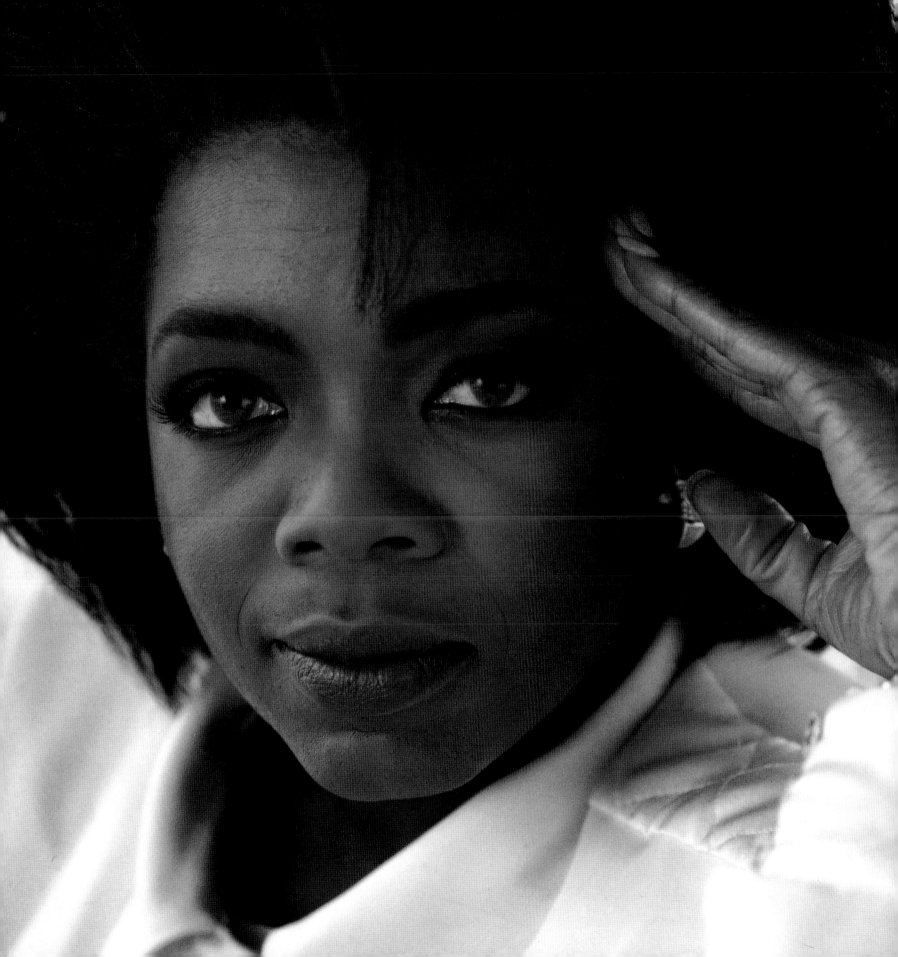

virginia woolf

by CLAUDIA ROTH PIERPONT

THE LITERARY CRITIC Queenie Leavis, who had been born into the British lower middle class and reared three children while writing and editing and teaching, thought Virginia Woolf a preposterous representative of real women's lives: "There is no reason to suppose Mrs. Woolf would know which end of the cradle to stir." Yet no one was more aware of the price of unworldliness than Virginia Woolf....

Her imaginative voyages into the waveringly lighted depths of *Mrs. Dalloway* and *To the Lighthouse* were partly owed to a freedom from the literal daily need of voyaging out—to the shop or the office or even the nursery. Her husband, Leonard Woolf, believed that without the aid of her inheritance his wife would probably not have written a novel at all. For money guaranteed not just time but intellectual liberty. "I'm the only woman in England free to write what I like," she exulted in her diary in 1925, after the publication of *Mrs. Dalloway* by the Hogarth Press, which she and Leonard had set up to free her from the demands of publishers and editors. What she liked to write turned out to be, of course, books that gave voice to much that had gone unheard in the previous history of writing things down: the dartings and weavings of the human mind in the fleet elaborations of thought itself.

More than any other writer, Woolf has shown us how the most far-off tragedies become a part of the way we think about our daily expectations, our friends, the colors of a park, the weather, the possibility of going on or the decision not to.

The old image of Virginia Woolf the snob has largely given way to various loftier characterizations: Virginia Woolf the literary priestess, or the Queen of ever-titillating Bloomsbury, or—most influentially—the vital feminist whose requisite "room of her own" came to seem the very workshop in which such books as *The Second Sex* and *The Feminine Mystique* were later produced. Recently, however, Woolf has been granted a new role in the all too modern female pantheon: the victim. The discovered molestations of her childhood, the bouts of madness that led to her suicide, seem now to commend rather than to qualify her right to speak for women. But Woolf's personal example is in the strength and the steady professionalism that kept her constantly at work—the overambitious failures as sweated over as the lyric triumphs. For all her fragility as a woman, she was a writer of gargantuan appetite, and she knew full well how much she intended to enclose in her fine but prodigious, spreading, unbreakable webs. "Happier today than I was yesterday," she wrote in her diary in January 1920, "having this afternoon arrived at some idea of new form for a new novel. Suppose one thing should open out of another...only not for 10 pages but for 200 or so—doesn't that give the looseness and lightness I want; doesn't that get closer and yet keep form and speed, and enclose everything, everything?"

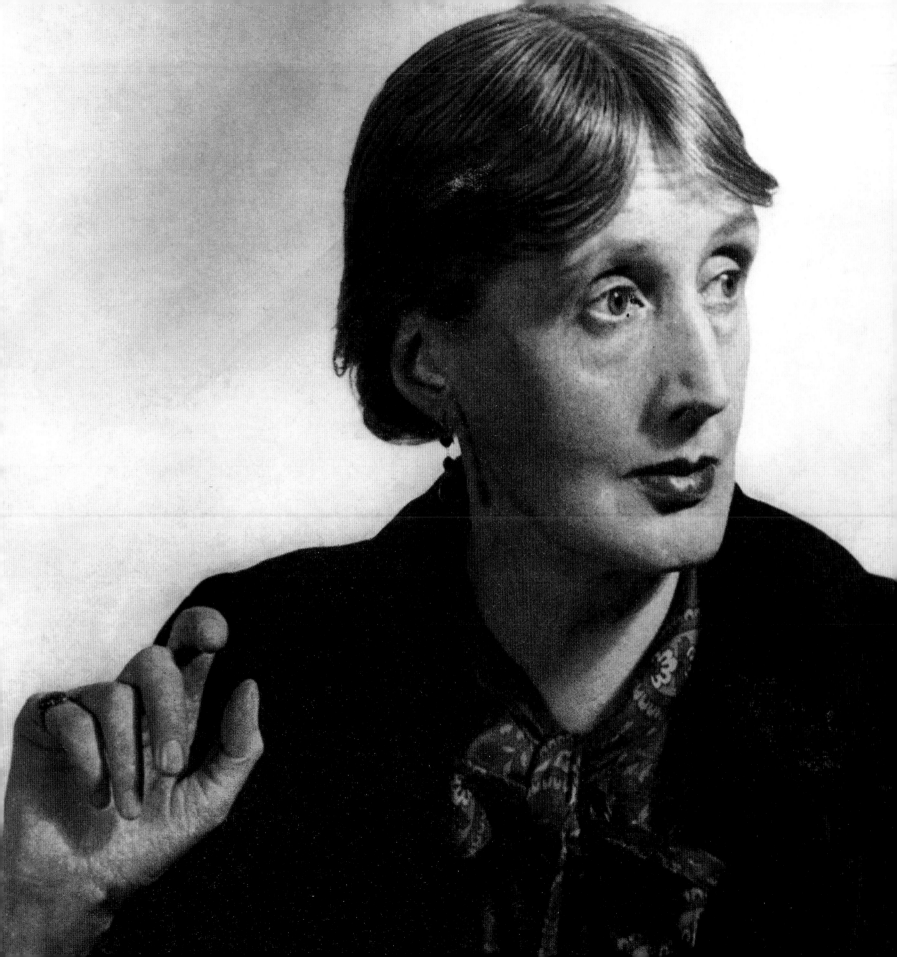

harriet tubman

by DARLENE CLARK HINE

HARRIET ROSS TUBMAN has achieved mythic fame as the best known conductor on the Underground Railroad. Her heroic exploits included at least fifteen trips into the South to rescue over 200 slaves and deliver them to freedom. Since Underground Railroad operators did not keep records of their activities, the exact number of trips Tubman made is unknown. Tubman herself remembered the number as eleven....

In 1844, Harriet married John Tubman, a free Black man. Harriet yearned to be free, but John failed to share her mounting anxiety of being sold into the Deep South or of the possible dispersal of her family should her owner die. In 1849, upon learning that her worst fears were soon to become reality, Harriet escaped....

After her escape, Tubman made her way to Philadelphia where she worked as a domestic, saving her meager earnings until she had the resources and contacts to rescue her sister, Mary Ann Bowley, and her two children. This was the first of many rescue missions Tubman would undertake as an agent of the Underground Railroad, a network of way stations situated along several routes from the South to the North to Canada, providing runaways with assistance in the form of shelter, food, clothing, disguises, money, or transportation. Most conductors on the Railroad who ventured South to seek prospective escapees and to guide them to freedom were Black station masters. In her numerous trips South, Tubman followed various routes and used different disguises. She might appear as a hooded, apparently mentally impaired, wretchedly dressed man loitering about or talking in tongues or as an old woman chasing hens down the street. She usually chose a Saturday night for the rescue since a day would intervene before a runaway advertisement could appear. She carried doses of paregoric to silence crying babies and a pistol to discourage any fugitive slave from thoughts of disembarking the freedom train. Within two years of her own escape she had returned to Maryland's eastern shore to lead more than a dozen slaves to freedom in northern states....

Frederick Douglass wrote to Harriet Tubman on August 28, 1868, and eloquently summed up her life.

The difference between us is very marked. Most that I have done and suffered in the service of our cause has been in public, and I have received much encouragement at every step of the way. You, on the other hand, have labored in a private way. I have wrought in the day—you the night. I have had the applause of the crowd and the satisfaction that comes of being approved by the multitude, while the most that you have done has been witnessed by a few trembling, scared, and foot-sore bondmen and women, whom you have led out of the house of bondage, and whose heartfelt "God bless you" has been your only reward. The midnight sky and the silent stars have been the witness of your devotion to freedom.

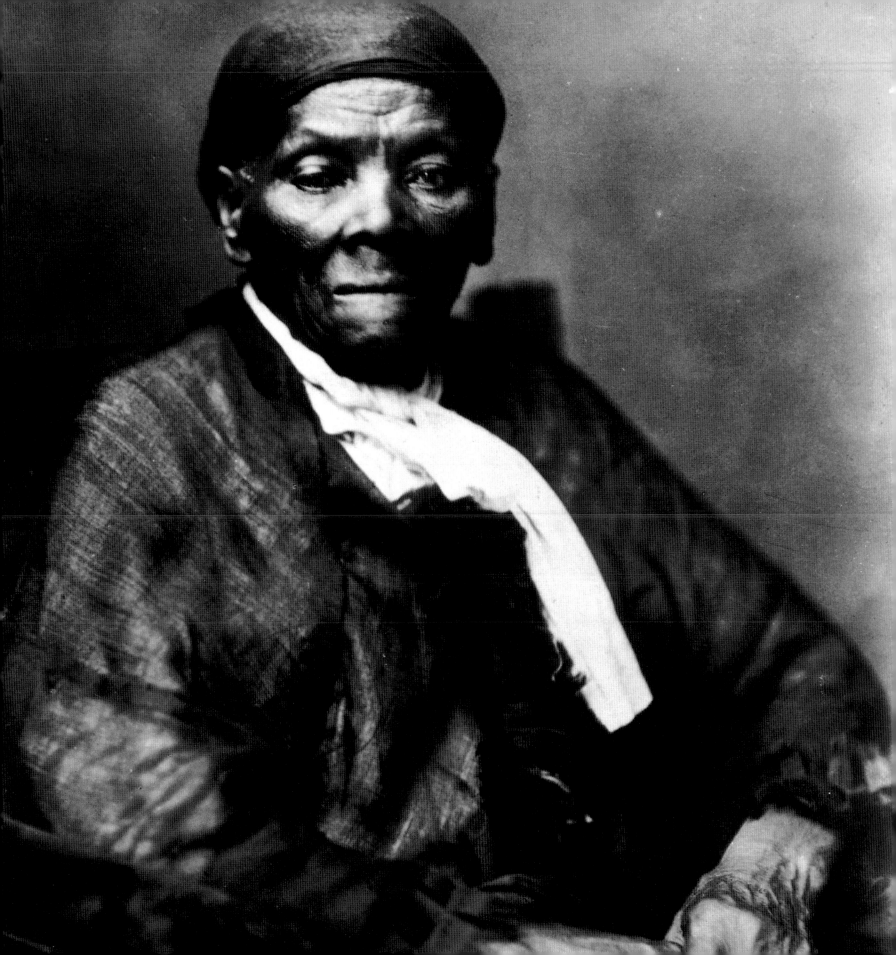

jane goodall

by VIRGINIA MORRELL

JANE GOODALL ARRIVED in Kenya from England in 1957, aged 24. She contacted [Louis] Leakey, curator of Nairobi's Coryndon Natural History Museum (today the National Museums of Kenya), on a friend's advice. Leakey offered her a job as a secretary but soon afterward confided that he had bigger things in mind: If she was willing to go, he would find funds to send her to Tanzania to study chimpanzees there.

In June 1960, she stepped into the forest at Gombe Stream on the shores of Lake Tanganyika, where her determination and skill in watching quickly produced results. Only 3 months into her study, she observed behaviors no researcher had ever reported: chimpanzees feasting on a wild piglet they had killed; chimpanzees hunting monkees; chimpanzees using tools made from twigs to extract termites from their nests.

That last finding blew apart anthropology's conception of primates—and human beings. "I was at the meeting in London in 1962 when Jane first came back and made that amazing announcement about chimps making tools in the wild," says Alison Jolly, a primatologist at Princeton University. "She essentially redefined what it is to be a human being. We'd all been brought up on 'man-the-tool-maker' and this just took it apart. Everyone knew that things would never be the same again."

Still, primatology was a bastion of male domination—and Goodall came under attack. The ruling animal behaviorists expected the animals to be numbered and placed in general categories, such as "the male" and "the female." Goodall chose to recognize chimpanzees as individuals instead.... In time, Goodall convinced other primatologists that what she was doing was indeed "appropriate science." ... Even empathy, the most "female" of traits, came to be seen by male primatologists as an important facet of observing primates in the wild....

Most of the remaining scientific critics were silenced in 1986 by Goodall's book *The Chimpanzees of Gombe.* A compendium of 25 years of research, filled with charts and graphs, the book demonstrated that she, too, could make "objective" generalizations about chimpanzees. But the essence of her work remained the perception of individual personalities within the primate group. And some female researchers admire her specifically for persisting in a "female" approach against the discouragement of the male scientific culture. "To succeed at a science, a woman has to do what a man does as well or better; it's why women are very hesitant to approach a field in a more female way," says Barbara Smuts, a primatologist at the University of Michigan, Ann Arbor. "Jane was a sterling exception. She never shied from addressing the chimpanzees' emotional nature, but went ahead and wrote what she saw."

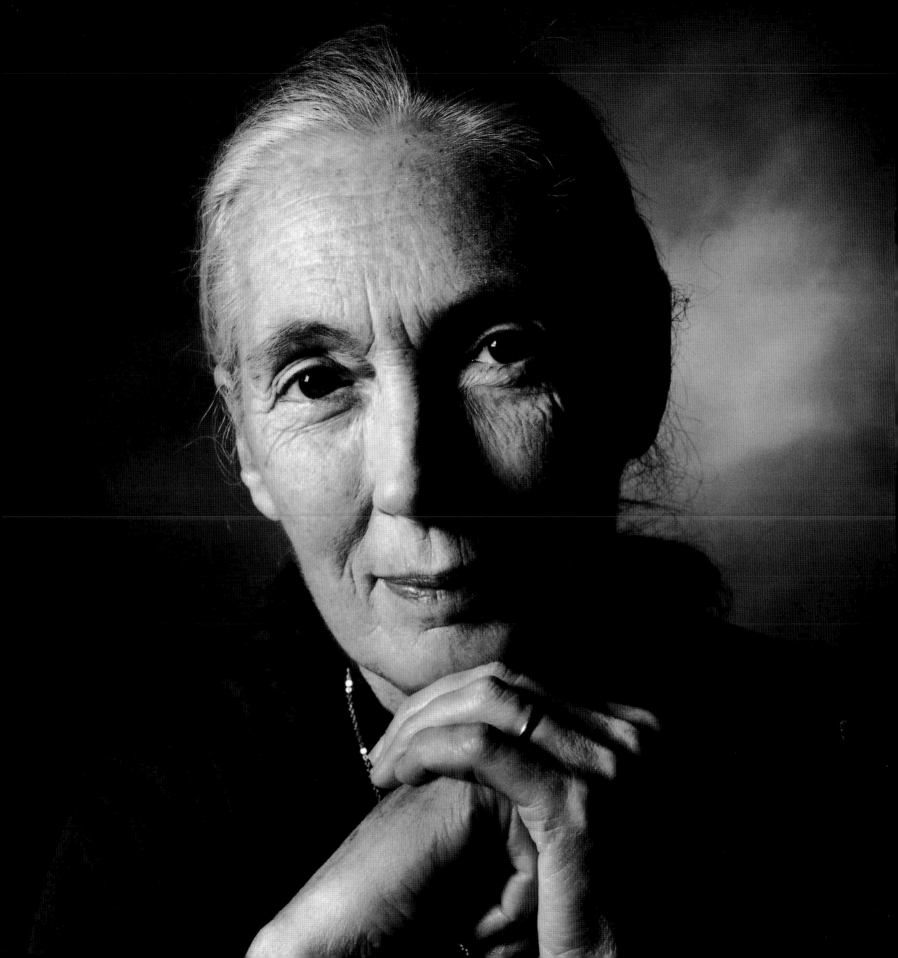

diana vreeland

by NANCY FRANKLIN

OR DIANA VREELAND, necessity was the mother of self-invention. In the late 1930s, when she was a young New York matron who had never seen the inside of an office, she got a job at *Harper's Bazaar.* Almost overnight, she became its fashion editor, and for the next several decades, until 1971, when she was abruptly fired from the editorship of *Vogue,* Vreeland was the undisputed queen bee of the fashion world, always rushing forward, ripping up issues at the last minute, exhorting photographers and designers and her harried staff to do it fast and make it new. "I'm always looking for the suggestion of something I've never seen" was the energizing and exhausting credo with which she set the fashion world on its ear time and time again....

Vreeland's peculiarly vivid appearance and manner and her regally nutty pronouncements made her almost a self-parody, but [we see] the self beneath the lacquer of parody...[A]t a moment when Vreeland was at her most vulnerable—she had just lost her job and had not yet joined the Costume Institute at the Metropolitan Museum—[she was] at her most resilient, buzzing around her Park Avenue apartment after a restorative trip to Europe, organizing a dinner party that she can't afford. "I'm back up on my horse," she says on the telephone. "Full gallop!"

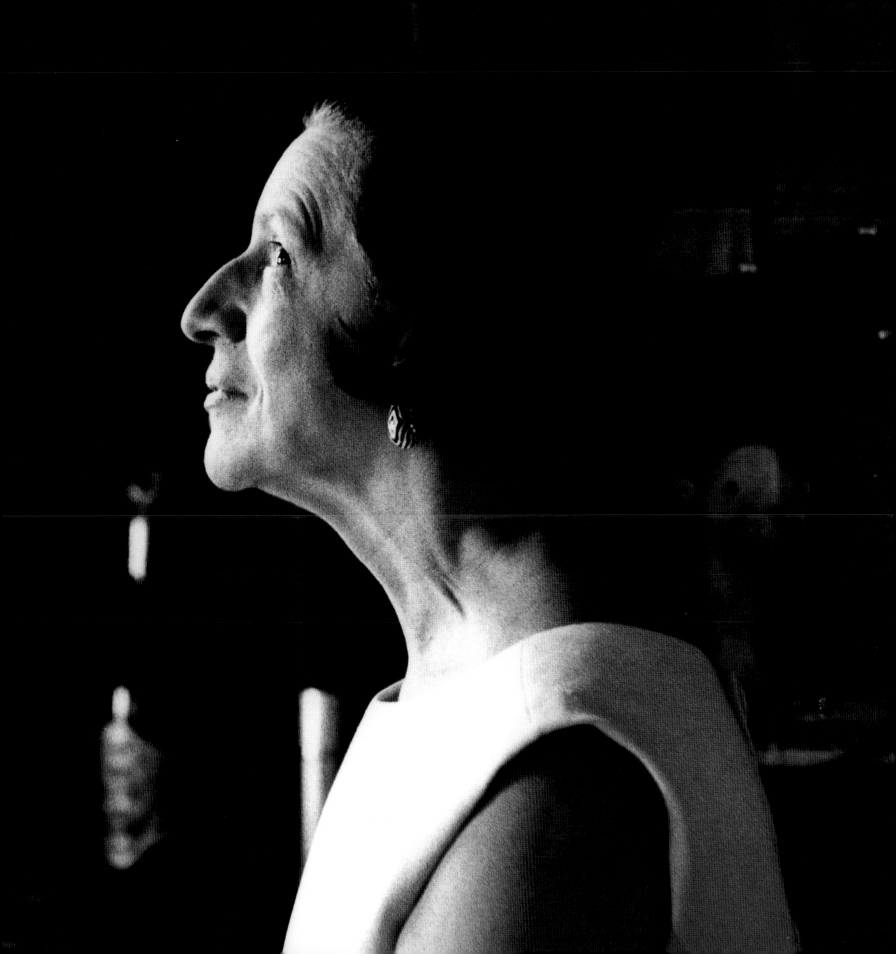

angela davis

by KATHLEEN THOMPSON

SHOUTS OF "FREE ANGELA" echoed across the early 1970s, and a California college professor became an icon of the counterculture. She was fierce, brilliant, and uncompromising. Angela Davis was born on January 26, 1944, in Birmingham, Alabama, the youngest child of B. Frank and Sallye E. Davis. In the segregated schools Davis attended, there were teachers who went out of their way to teach Black history and instill a sense of Black heritage, but there were also school buildings near to falling down and textbooks long out of date. She became aware of the messages Black children were being sent by their teachers and others around them. If their parents were poor, the system told them, it was because they did not work hard enough, were not bright enough, did not have enough determination. Davis ferociously resented these messages and believed they were undermining a whole generation.... In 1967, she made a choice that would drastically change her life: she joined the Communist party....

Davis became more and more involved in work with the Black Panthers, especially with prison inmates, whom she considered prisoners of class war. Then two Marxist inmates of Soledad Prison organized a revolutionary cell in the prison. One of the inmates, W. L. Nolen, was killed by a guard while involved in a fistfight with two other prisoners. The other, George Jackson, was indicted for murder when a white guard was found murdered.... Jackson had taken the guns he used in the rescue attempt from Davis's home. Though the guns had been purchased by Davis because of threats on her life, and though they were registered, a federal warrant was issued for her arrest. She did not wait to be served with the warrant; she went underground. On August 18, 1970, the brilliant middle-class professor of philosophy whose crime consisted of owning guns used in a crime was placed on the Federal Bureau of Investigation's ten-most-wanted list. She was charged by California with kidnapping, conspiracy, and murder. After two months, she was found in New York, extradited to California, and put in jail without bail.

The "Free Angela" movement erupted. The slogan appeared on urban walls, on bumper stickers, and in newspapers. Her face appeared on posters and on T-shirts. Singer Aretha Franklin offered to pay her bail, saying "I'm going to set Angela free...not because I believe in communism but because she's a Black woman who wants freedom for all Black people." On February 23, 1972, she was released on $102,000 bail and, at her trial, she was acquitted of all charges.... The defense committee set up for Angela Davis was renamed the National Alliance against Racism and Political Repression, with Davis as cochair. Its purpose was to help in the defense of political cases. The majority of those defended have been Blacks and Hispanics.

martha stewart

by PATRICIA MCLAUGHLIN

NATURALLY, PEOPLE HATE Martha Stewart. She's rich. She's blond. And now, she's even thin. What's weird is what they claim to hate her for. *Newsweek* accused her of being "perfectly perfect," joshing that "on a typical morning, she's already fed the chickens, built a toolshed, and launched a new business by the time the rest of us are stumbling into the shower." *The New Republic* made fun of her for owning too many gardening tools, including loppers in three sizes. Critics seize upon her divorce as if it were a smoking bun: Little Miss Domesticity couldn't keep a husband. They complain about how Waspy she is or, if they know she's Polish and Catholic, about how Waspy she looks.

Too perfect. Divorced. Waspy-looking. Too many loppers. *What?*

"All I do," says Stewart in her own defense, is "write cookbooks and teach people how to do good things." The trouble is, she is doing it at a time when housekeeping is fraught with anger and, paradoxically, longing.

Her audience is the last generation of Americans to have grown up with truly clean floors. And like Meg in *Little Women*, who found poverty harder to bear than her sisters because she remembered when they were rich, many of us are beginning to miss those clean floors and the other benefits of good housekeeping—order, beauty, comfort, warmth. It's not that we want to go back (as if we had the choice). But, good as it is not to have to hang our whole identities on clean floors, it's also good to have them. And we haven't figured out how to have it both ways.

Which is where Stewart comes in. To two million readers, most of them managers and professionals, her magazine presents the prospect of coming home to something more pleasant than ambient mess and frozen fish sticks. It offers opportunities to do something right for a change—whether it's building a window box or baking a loaf of eight-grain bread—without compromises, memos, and budget constraints.... If you were socialized to be Suzy Homemaker, as most older boomer women were, and ended up being a lawyer, somebody's trousseau—or Martha Stewart telling you how to rag your bathroom walls—reminds you of the road not taken.

Why not just ignore her then? Because she's useful.

Lots of women, especially women with children and jobs, already have too much to do and nowhere near enough time to do it. You see them zoned out in their rare moments of forced idleness at stoplights or in the checkout line, clicking through the agendas in their heads—8 o'clock meeting, plumber, grass seed, groceries, dry cleaner....

Then when perfect Martha, with her Armani suits and her three sizes of loppers, helpfully suggests that they invest a few spare hours in cake decorating, all of that never-enough-time finds its flash point.

And hating Martha Stewart is safer than hating your whole life.

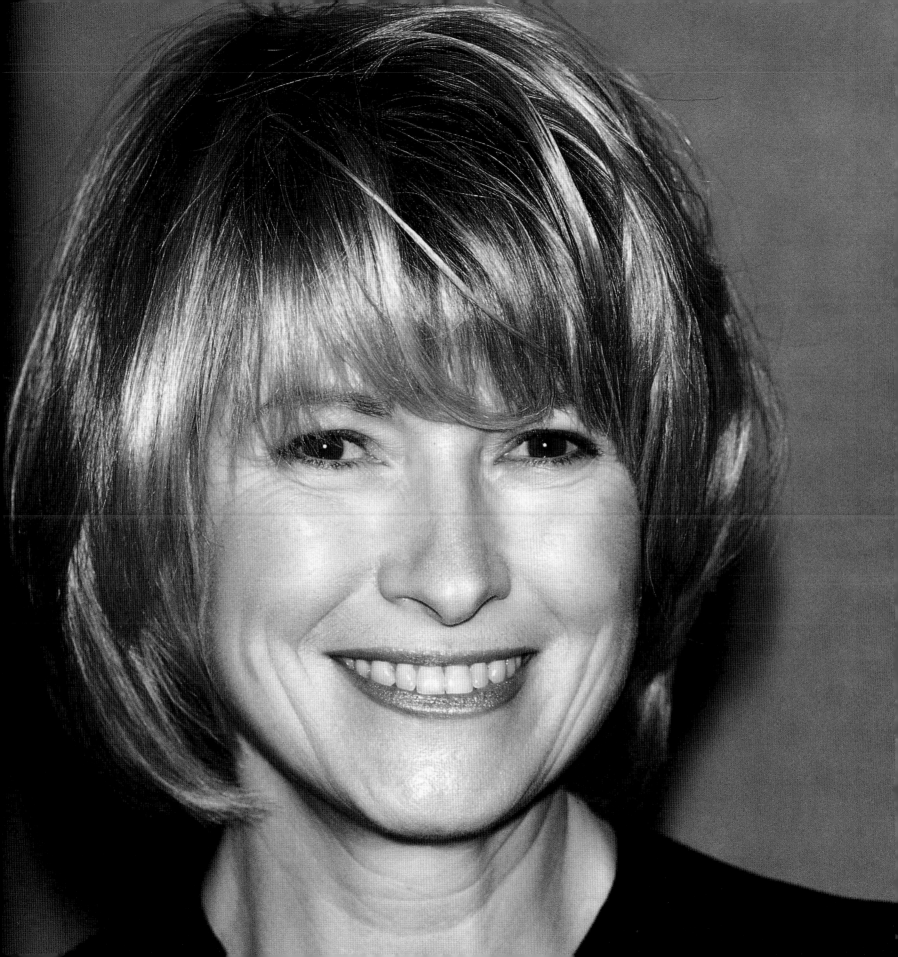

aung san suu kyi

by GAYLE KIRSHENBAUM

ON APRIL 5, 1989, Aung San Suu Kyi was walking down a road in the Burmese village of Danubyu when a group of soldiers stopped her. It wasn't the first time that she'd been harassed by Burma's repressive military regime while campaigning for the return of democracy there. But this time, six of the soldiers jumped out of a jeep, crouched down, and on the orders of their captain, aimed their guns at her and prepared to fire. Aung San Suu Kyi waved away her supporters and walked toward the soldiers alone. "It seemed so much simpler to provide them with a single target than to bring everyone else in," she later explained. At the last minute, the order to shoot was reversed.

Not long before that day in Danubyu, Aung San Suu Kyi had written that courage "comes from cultivating the habit of refusing to let fear dictate one's actions." She was reflecting on the bravery of her father, Aung San, who led the struggle against British colonial rule, and who was assassinated by a political rival just before Burma gained independence in 1948. Aung San Suu Kyi was two years old. She later took it upon herself to study his life, which came to foreshadow her own. Three months after her showdown with the army, she was placed under house arrest and was told she could gain her release only if she agreed to leave the country. She refused, and for the next six years was confined to her home in Rangoon.

Aung San Suu Kyi was finally freed unconditionally.... The growing threat of an international economic embargo at a time when Burma is in dire need of foreign investment forced the generals to deal with their biggest public relations problem.... Her courage was recognized in 1991 when Aung San Suu Kyi became only the eighth woman in history to receive the Nobel Peace Prize—an award she was unable to accept in person because of her confinement.

Since her release she's been visited by her family, but refuses to leave the country for fear that she'll be prevented from returning. Although the threat of violent reprisals endures, Aung San Suu Kyi continues to speak out. In a videotaped speech delivered at the NGO (nongovernmental organizations) Forum on Women in China, she maintained that "it is time to apply in the arena of the world the wisdom and experience" that women have gained "in activities of peace over so many thousands of years."

Asked if she thinks of herself as a role model, she responds as if she had never before considered the notion. "I don't really know what that means," she finally replies. "There were many in Burma who did more, but the world doesn't know about them. I had the protection of my family name."

Aung San Suu Kyi acknowledges the exceptional natures of leaders like her father and Mahatma Gandhi. But of herself, she simply says, "I did what I felt I had to do."

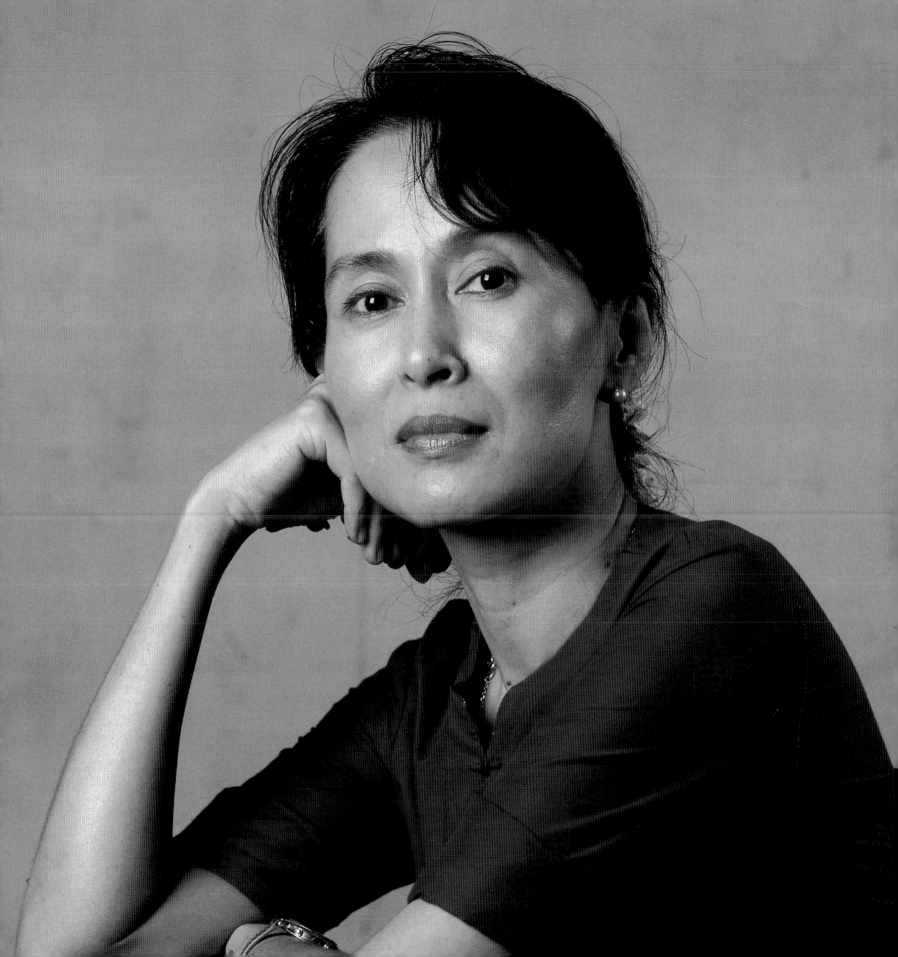

mary mccarthy

by CATHLEEN MCGUIGAN

SHORTLY BEFORE PUBLISHING her notorious best-selling novel about Vasssar girls, *The Group*, in 1963, Mary McCarthy told the *Paris Review* that she'd grown bored with the "quest for the self." What you feel when you're older is that you really must *make* the self," she said. "You finally begin . . . to make and choose the self you want." When she died at 77, McCarthy had not only written some of the most pungent criticism of her time—as well as journalism, cultural history, fiction, and memoirs—she'd also created a legendary persona: moralistic, biting, satiric. As queen of the American literary scene, she was as famous for her feuds—notably with Lillian Hellman—and her love affairs as she was for the piercing intelligence and savage wit of her prose. . . .

McCarthy's second husband, the critic Edmund Wilson, with whom she had her only child, a son, got her to try writing fiction. Her first novel, *The Company She Keeps* (1942), was scandalous in its day for its description of a seduction aboard a Pullman car. The book was autobiographical, and at moments she skewered the heroine—herself—as mercilessly as she would any enemy, for her pretensions and insecurities. Fiction or note, McCarthy's writings reflected her politics, from her anti-Stalinism in the '30s through her essays about the Vietnam War and Watergate. In a cynical age, she asked moral questions—and she was unforgiving to those who sank below her standards for truth and impeccably reasoned discourse.

No one felt neutral toward her. She possessed "a wholly destructive critical mind," said Alfred Kazin, while Elizabeth Hardwick maintained that "the purity of her style and the liniment of her wit . . . softened the scandal of the action or the courage of the opinion." Lillian Hellman sued her for $2.25 million after McCarthy said on the Dick Cavett show that "every word [Hellman] writes is a lie, including 'and' and 'the'." McCarthy charged that the playwright exaggerated her self-described heroism during McCarthy-era witch hunts. Hellman died before the suit was settled.

Though McCarthy relished a fight, she had a soft side. As a child, she'd dreamed of becoming a nun—or an actress. She'd been a beauty, and the toughmindedness hid a girlish streak of romance. She recalled going to a Trotskyite meeting one February day in the '30s and thinking, "I'm the only person in this room who realizes that it's Valentine's Day!" In her fourth marriage, to ex-diplomat James West, McCarthy found happiness. The couple split their time between Paris and Maine. "Everyone needs the good, hankers for it, as Plato says, because of the lack of it in the self," she wrote. "This greatly craved goodness is meaning, which is . . . incommensurable with reason."

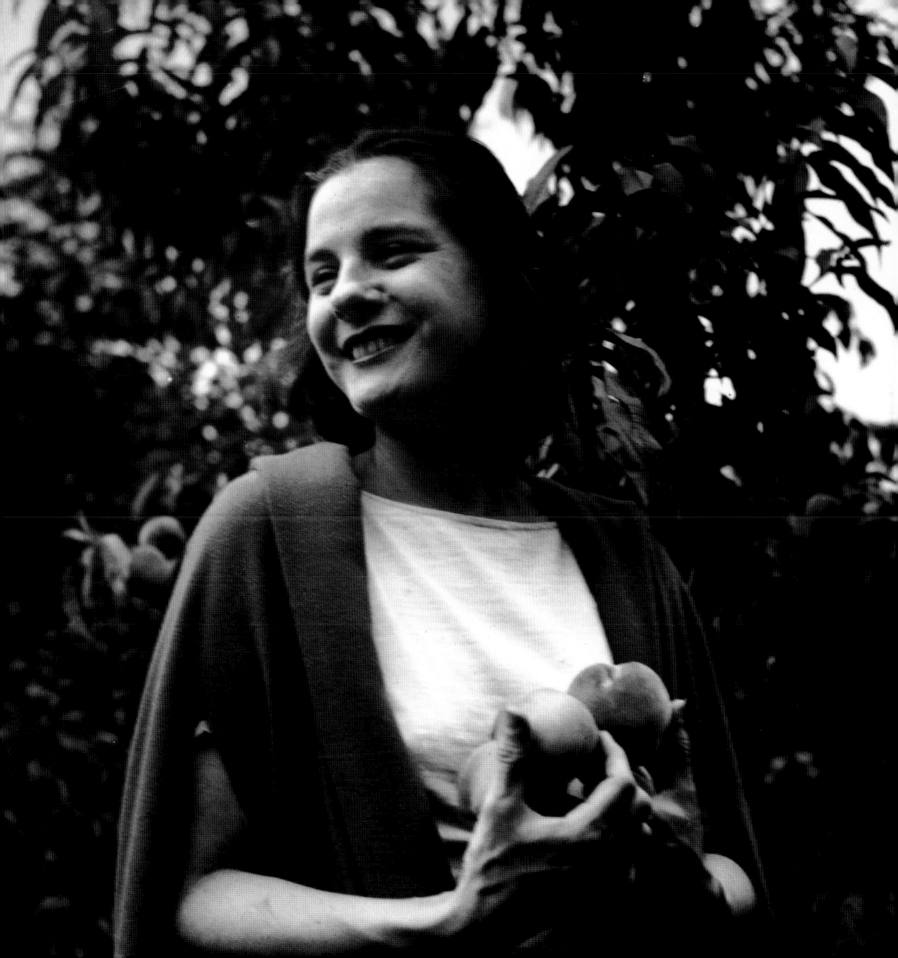

joan baez

by HIMILCE NOVAS

JOAN BAEZ WAS BORN Joan Chandos Baez in Staten Island, New York, on January 9, 1941, to Albert Baez, a physicist who came to America at age two from Puebla, Mexico, and Joan (Bridge) Baez, born in Edinburgh, Scotland, and raised in the United States. Her parents' Quaker beliefs of nonviolence engendered in Joan a devotion to issues of justice and peace, which was fueled by the discrimination she endured in childhood. Joan's classmates ostracized her because of her Latino roots and dark complexion, and this treatment left an indelible mark on her psyche. As an escape from prejudice, Joan immersed herself in music, spending a summer developing her voice and learning to play the ukulele....

In 1959, Baez sang for several weeks at the Gate of Horn, a nightclub in Chicago, where she met pop folk singer Bob Gibson. Gibson invited the teenage singer to appear with him that August at the first Newport Folk Festival. Singing as an unlisted entertainer, Baez stole the show and became an overnight celebrity....

Before Christmas in 1960, the singer's first solo album *Joan Baez* was released. On November 23, 1962, *Time* magazine caught the Baez fever by featuring the singer on its cover holding a guitar. In 1963, Baez's third album, *Joan Baez in Concert*, was released, and she performed at the Forest Hills Music Festival and the Hollywood Bowl....

In the 1960s, Baez took an active role in the civil rights movement and the Vietnam War protest. In 1962 she joined Martin Luther King, Jr. at a banned march in Birmingham, Alabama, risking both her life and career. She marched with King again in 1963 in Montgomery, Alabama, and on August 28, 1963, led 350,000 people in "We Shall Overcome" at the Lincoln Memorial when King gave his "I Have a Dream" speech....

In 1965, the Daughters of the American Revolution refused Joan Baez permision to play at their Constitution Hall in Washington, D.C., because of her stance against the war. Mo Udall, secretary of the interior, granted the singer permission to give an outdoor concert at the base of the Washington Monument where an estimated 300,000 people gathered to hear her sing. Several months later, Baez was arrested and jailed for her civil disobedience in opposition to the draft.

Since 1973, Joan Baez has served on the national advisory board of Amnesty International. She was instrumental in forming Amnesty West Coast, a California branch of the organization. In 1979 she founded the Humanitas International Human Rights Committee, whose purpose was to address global human rights violations....

To this day, Joan Baez continues to advocate an end to violence and war in the world and to help those less fortunate at home and abroad.

beryl markham

by DIANE ACKERMAN

ERYL MARKHAM WAS one of the most extraordinary of explorers. But she was also an emotionally deprived child and, as an adult, a serious outlaw of love. She died in 1986 at the age of eighty-three; that year was the fiftieth anniversary of her historic solo flight across the Atlantic. Not much remains to shed light on her. There is her beautifully imagined memoir, *West with the Night*, published in 1942 when she was forty years old, a triumph of adventure writing, set largely in Africa, which Hemingway called "bloody wonderful," and praised at great length, conceding "this girl can write rings around all of us." ...

Imperious, ravishingly beautiful, and fluorescent with life, she charmed her way from one continent to another. Though men balked at her flagrant promiscuity, it didn't stop them from being drawn to her. Her lovers included some of the most famous artists, adventurers, and scoundrels of her day. But then, she herself was a scoundrel. She never let a lie stand in the way of what she desired. She envied lives of fame and adventure; the irony is that she couldn't see how packed with color, adventure, and accomplishment her own life was.

A pioneer of aviation, she was the first person to fly solo from west to east across the Atlantic, in September 1936, and the details of the flight are hair-raising.... When her engine quit, she made an emergency landing in a rock-strewn peat bog in Nova Scotia which, from the air, had looked like a safe green field. Amazingly, she walked away from the nose-in crash with only a small head injury, though the plane was destroyed. New York City, her original goal, gave her a ticker-tape parade, and she was lionized for her daring and skill. It seemed impossible that so beautiful a woman could be so masterful. What they didn't realize is that she had had a lot of practice flying around Africa, often at night, always with no radio or air-speed indicator and very few instruments. Bush flying at that time, over such wilderness, in such primitive planes, was unthinkably dangerous. A forced landing often meant death from the crash or from starvation, thirst, or wild-animal attack. At the age of thirty-one, she was the first woman to hold a commercial license in East Africa, and that required her to be able to strip down and repair an airplane engine. She ferried people to distant farms, acted as a game spotter for some of the great hunters, and ran an informal aerial-ambulance service. She carried mail to the gold miners in Tanganyika. She often rescued pilots who had crashed. Thinking they were doomed, they would see a plane land brilliantly in the bad terrain, then a willowy figure climb out, dressed like a *Vogue* model in the white silk blouse that was her trademark, pale trousers, a silk scarf at the neck, her hair coiffed and her fingernails carefully painted, handing them a flask of brandy and grinning.

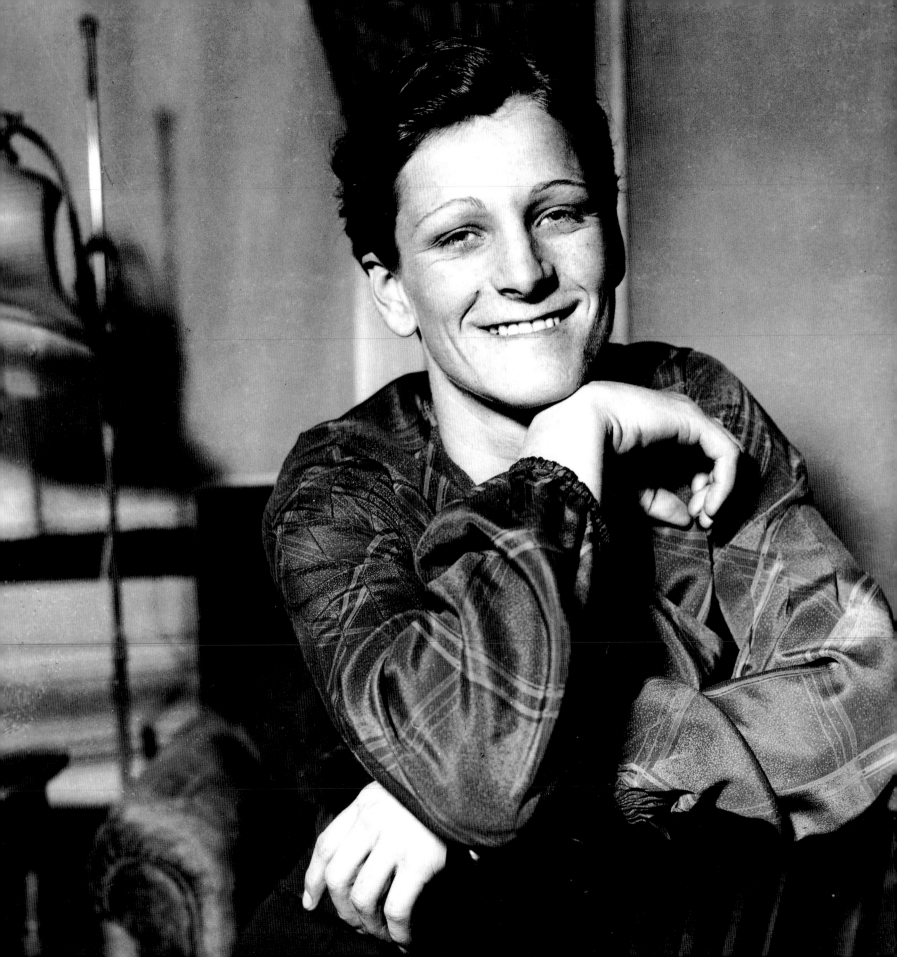

babe didrikson zaharias

by SUSAN E. CAYLEFF

ONE OF THE MOST GIFTED athletes of all time, Babe Didrikson Zaharias dominated track and field, winning two Olympic gold medals and a controversial silver in 1932 before going on to compete in baseball, bowling, basketball, tennis, and particularly in golf. An American public smitten with her wit, frankness, and "unladylike" bravado helped her become an American legend. . . .

As a protagonist, Babe Didrikson elicits as much frustration and dislike as she does admiration and idolatry. She was a sports hero in a century when sports heroes were nearly always male; she was southern, working-class, and ethnic; she was unfeminine, coarse, and loud—all the things that make for a female antihero.

Didrikson's fame, broadcast as it was all possible opportunities by Babe herself, was legendary. Several contemporary writers likened her recognizability and appeal to Eleanor Roosevelt's, a comparison Babe surely found suitable, pleasing, and earned. Her appeal expanded beyond that of a typical sports figure. She became a phenomenon, a personality. Her name, if not her image, became synonymous with excellence and fortitude. "You're another Babe Didrikson" resonated in the ears of a lucky few female athletes. Babe Didrikson Zaharias was a cultural hero, her household name used both as a compliment and a derisive put-down. She was a superb athlete in several sports, a medical humanitarian who went public with cancer, a co-founder of a professional women's sports association, and a larger-than-life Texan who owned the American public with her brassiness, quick quips to the press, and unconventional behavior. She was a character. She was larger than life. . . .

Babe Didrikson died in 1956 after composing her autobiography while rebounding from a grave illness in 1954. She told a life story that, as one feminist historian studying the craft of biography noted, presented as fact established opinions of the age. She was nostalgic to revive the past and knew well that hers was an extraordinary personality and an eventful life. Babe shared these motivations with many others who choose to record their lives. She revealed no anger toward an often vicious press and public and her self-serving husband. She displayed her powerlessness in her private realm as a badge of achievement and normalcy and minimized her infuriating lack of control over athletic authorities, social class conflicts, heterosocial ideals, and disintegrating health.

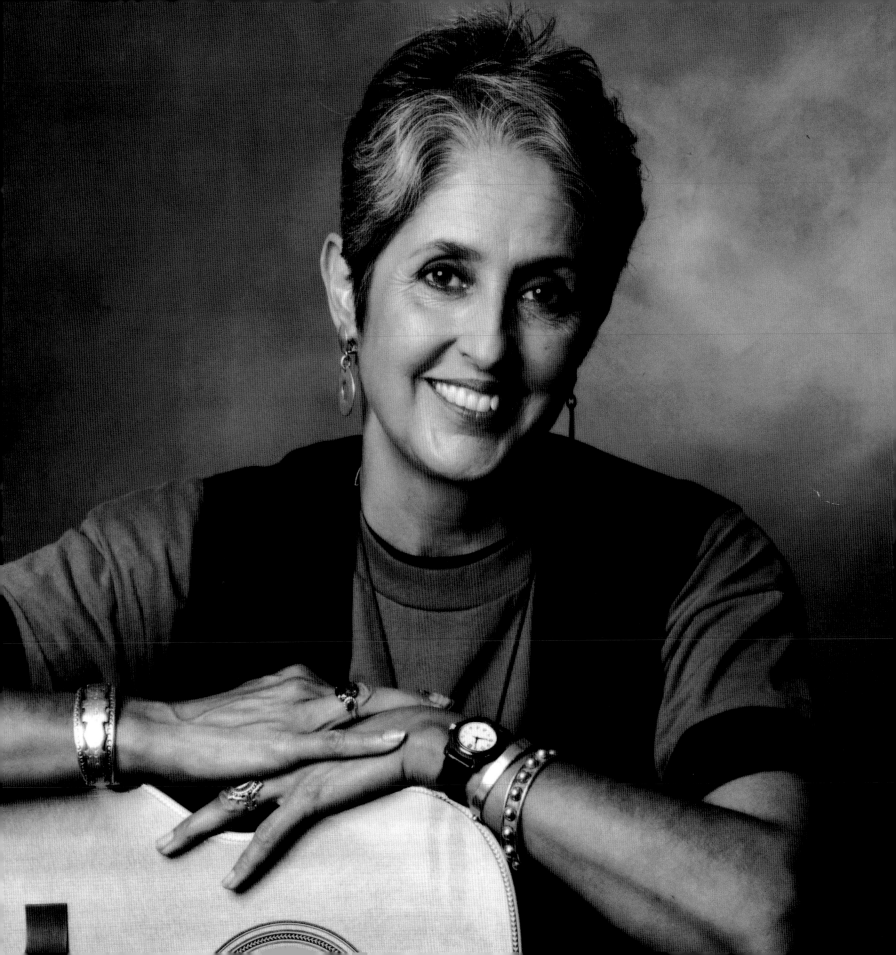

katharine graham

by MARY ROWLAND

THE MASS OF PHOTOGRAPHS on the wall behind Katharine Graham's desk gives clear witness to her position among the wealthy and powerful. Indeed, as chairman and CEO of the $1.4 billion Washington Post Company, Graham is routinely referred to as the most powerful woman in the country....

The first big test of Graham's courage... came before Watergate.... In June 1971 the *New York Times* was restrained by the courts from continuing to publish the Pentagon Papers, a secret Defense Department history of the Vietnam War. The *Post* quickly obtained its own set of the papers, and executive editor Ben Bradlee rushed some of his top reporters to his home to prepare stories.

The *Post's* lawyers and top business people, concerned about the impact on the company's stock if the *Post* violated a court order, joined them. As the deadline approached and the editors and business people could not agree, they called Graham and outlined the issues. The company had gone public just two days before; there were some very grave risks; and the business and legal people advised against publishing. But the editorial side argued that backing off would be seen as cowardly. It would violate the people's right to know, and it would put the *Post* on the side of the government, against the *Times.* The *New York Times* had taken more than three months to make the decision. In a matter of minutes, Graham decided to go ahead. "The decision was hers alone," Bradlee says, "and it was the most important editorial decision of the last 25 years. She did it against the popular wisdom of all her colleagues except the news side. It was a very dramatic moment."...

For months and months the *Post* was the only major newspaper reporter on Watergate. This gave Graham and Bradlee some pretty tense moments. They had two young reporters on the story who said they couldn't name their sources. "Being alone had its chilling moments," Graham says. "You thought, 'If this is such a hell of a wonderful story, where is everybody else?'" Graham lost sleep, but she didn't hesitate. She continued to publish. "The image of me as someone who likes or can deal with a fight is wrong," she says. "Some people enjoy competition and dustups, and I wish I did, but I don't. But once you have started down the path, then I think you have to move forward. You can't give up." By the time President Richard Nixon resigned, the media were all over the story. But the *Washington Post* had changed the course of history....

"It's one hell of a story," (investor Warren) Buffet says, "because she really did walk in there without formal business training and with a temperament that did not make these things easy. But she has a great will to succeed and she did. It's like a stutterer overcoming the handicap and becoming a great public speaker."

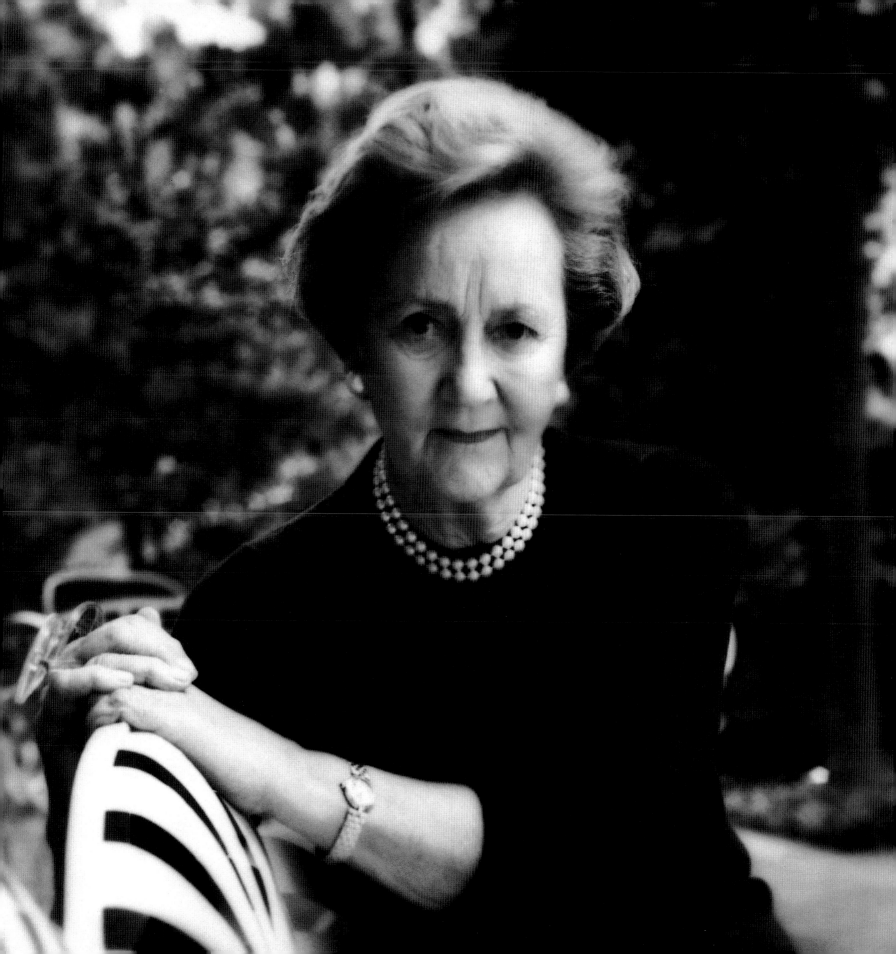

indira gandhi

by S. SUSAN JANE

INSPIRED BY HER PARENTS' POLITICAL ACTIVISM to free their country from British domination, Indira Gandhi became India's first woman prime minister.

Indira, the only child of Jawaharlal and Kamala Nehru, was greatly influenced by her parents—as well as by stories about Joan of Arc. By the age of twelve, she had established the Monkey Brigade, a children's organization engaged in the struggle for independence.

In 1947, India won its independence from Great Britain, and Jawaharlal Nehru became the country's first prime minister. Indira Gandhi acted as "first lady," accompanying her father on international travels, attending coronations, summits, and meetings with world leaders.

In 1959, Gandhi was elected president of the Indian National Congress party, the second highest political position in India. She assisted her father in leading the country until his death in 1964. At that time, Nehru's successor, Lal Bahadur Shastri, appointed Gandhi minister of information and broadcasting. In a land of widespread illiteracy, radio and television played an important role in disseminating information to the public. Gandhi . . . opened television and radio facilities to members of the opposition and independent commentators. For the first time, people were free to voice their ideas publicly—even if they were opposed to the government.

When Shastri died in 1966, Gandhi was selected to serve as prime minister until another election was held. The following year, she became the first woman ever elected to lead a democracy. As prime minister, Gandhi enhanced India's political power and improved its relations with the Soviet Union. She led India to a decisive victory in its war with Pakistan in 1971, and in the same year, sent India's first satellite into orbit. During the elections in 1971, Gandhi's campaign slogan was "Abolish Poverty." Although she won, her opponents accused her of violating election laws, and her leadership became vulnerable. In her next term, Gandhi instituted a voluntary sterilization program to limit population growth. Her political opponents attacked the program as compulsory, and criticism of her administration grew. Riots and protests ensued in 1975, forcing Gandhi to declare a state of emergency, which limited personal freedoms and called for the imprisonment of political opponents. She was voted out of office in 1977 but made a comeback in 1979.

Although support for Gandhi was strong, India's population grew, education standards plummeted, and strikers protested inflation. Gandhi also still faced opposition from the right wing as well as from two Communist parties. During another state of emergency in 1984, Indira Gandhi, who had dedicated herself to improving the quality of life in India, was assassinated by her opponents.

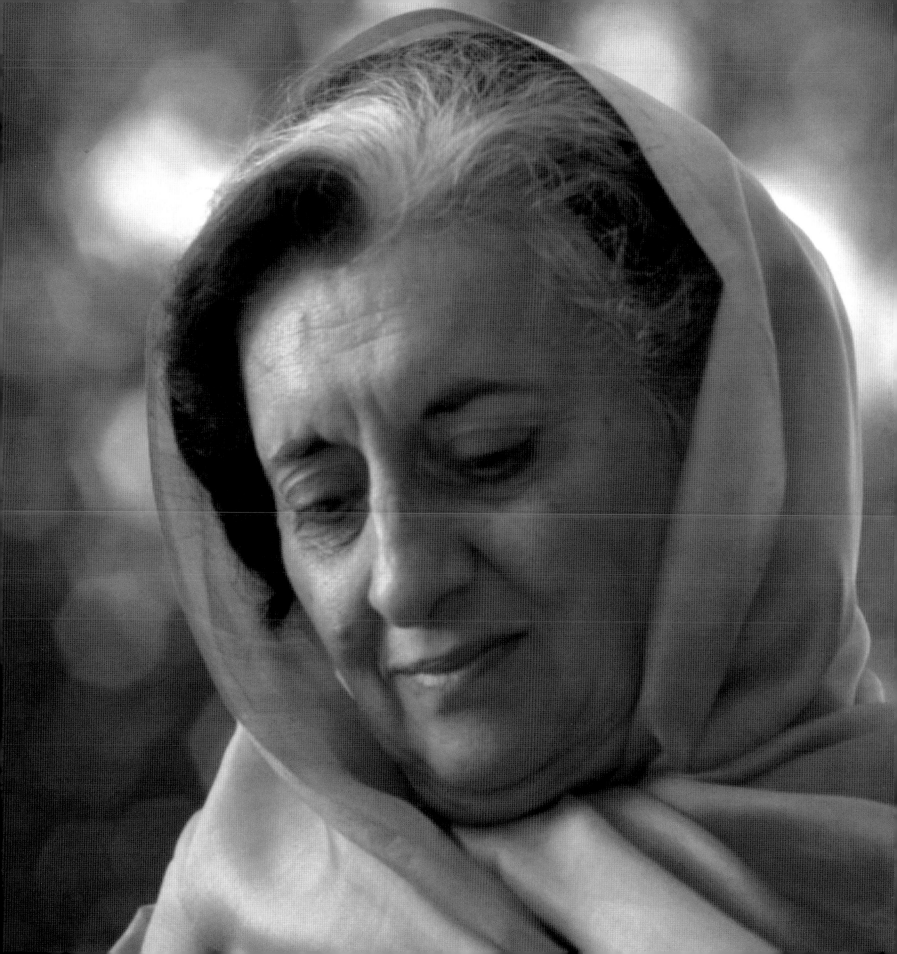

anne frank

by LIV ULLMAN

"I BELIEVE THAT DEEP DOWN, all human beings are really good."

I thought of those words of Anne Frank a few years ago, when I met a little boy in Somalia. A little boy who grabbed my finger and aimlessly led me around a refugee camp. A little naked boy with an empty plate and eyes, oh, a hundred years old, and a tiny behind as wrinkled as an old man's....

Listen, Anne Frank: How can all people really be good if he—like millions of other children who've had to give up their right to live, to smile, to learn, and to grow—has had to suffer so much?

You were so young, Anne Frank—your trust in humanity so extraordinary. Sitting there in your small loft. Writing. Hoping. Dreaming. Believing. Surrounded by so much evil. And finally, listening to Evil itself hammering on the door behind which you had been hiding for such a long time.

Did you *still* believe when they brought you to Auschwitz? When your mother was sent to her death? As your sister lay dying? And then *you*...?

More than forty years after you wrote your words, there is still war, poverty, child exploitation. One hundred million children are homeless around the world. Almost 40,000 children die from neglect daily, one every other second. We are defined by those deaths.

Anne asked, "Why can't people live with each other in peace? ... Why must everything be destroyed? ... Why must people go hungry while surplus food elsewhere in the world rots away? ... Oh, why are people so crazy?" Yes, why are people so crazy, Anne? Or would you today, as a sixty-year-old woman, have given it another name? "Why are people so *cynical?*" Maybe because it is easy and fashionable to be a cynic, to shrug one's shoulders and say, "Well, there's nothing I can do, really." It is easy to turn one's back, turn off the television news. But I ask you, where do the children turn? They do not disappear at the push of a TV button. Their suffering does not cease, their cries do not hush, even though we can't hear them.

Deprived of freedom, in a small loft, Anne painted a portrait of herself that has survived. Survived not only because of the circumstances of her life, but because of her belief in Life. Her belief in you and me. And in *our* ability to change. To protest. To care. To make good what is evil.

"I believe that deep down, all human beings are really good."

We owe it to her to listen. We owe it to her to be good. We owe it to her to believe in the *possibility* of Good, within all of us, and then in our daily life to *demonstrate* this belief. Because Anne believed in us.

In spite of everything.

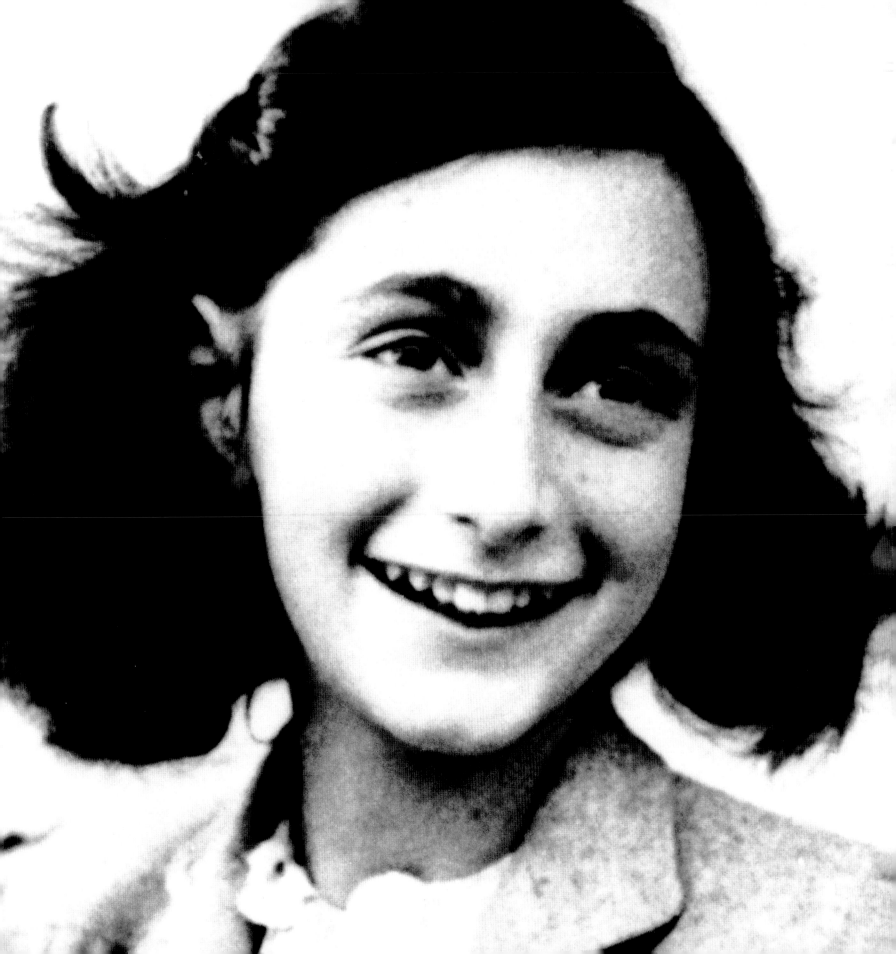

marian anderson

by JESSYE NORMAN

ARIAN ANDERSON WAS a woman of such quality, compassion, and modesty that her humanitarian efforts alone would warrant our adulation. But she was also blessed with a matchless voice—a voice with so much warmth, richness, and mobility that Arturo Toscanini was moved to call it a voice "heard once in a hundred years."

I became acquainted with this glorious sound at about age 10, through a recording of Brahms's Alto Rhapsody, and was so overwhelmed I wept, not really understanding why. When I was 16, in the early 1960s, I traveled by train from Augusta, Georgia, to Philadelphia to participate in the Marian Anderson Voice Competition. I was so young and thrilled at being there that I was unaware that perhaps I should have been anxious as well. I did not win a prize, but the gentleness and warmth of that experience remain with me to this day.

It was in Constitution Hall in Washington that I first heard Miss Anderson in person, in 1965. Her voice filled the vast space easily, whether singing Schubert at full strength or "Deep River" with a profound hush. She was queenly in her every gesture. In 1939, the Daughters of the American Revolution refused to permit her to perform in this hall on racial grounds. Eleanor Roosevelt broke ranks with her fellow D.A.R. members and helped arrange a concert at the Lincoln Memorial, a historic event that has been called America's first civil rights rally.

Miss Anderson and I both attended a Metropolitan Opera performance of *Les Troyens* in 1973, when I was privileged to meet her for the first time. She recalled having sung in Augusta some 20 years before, and I was happy to tell her that the city still thought of her visit not only as a watershed but also as a blessing. On the occasions when we were able to sit and talk, I found her interest in me flattering, but I preferred listening to her speak about herself. How could she show the world such poise when she was faced with touring a segregated United States? How could she not take exception to her exclusion from the Met until late in her career? How could she be so deeply spiritual without being at all sanctimonious?

She wore the glorious crown of her voice with the grace of an empress and changed the lives of many through the subtle force of her spirit and demeanor. If the planet Earth could sing, I think it would sound something like Marian Anderson.

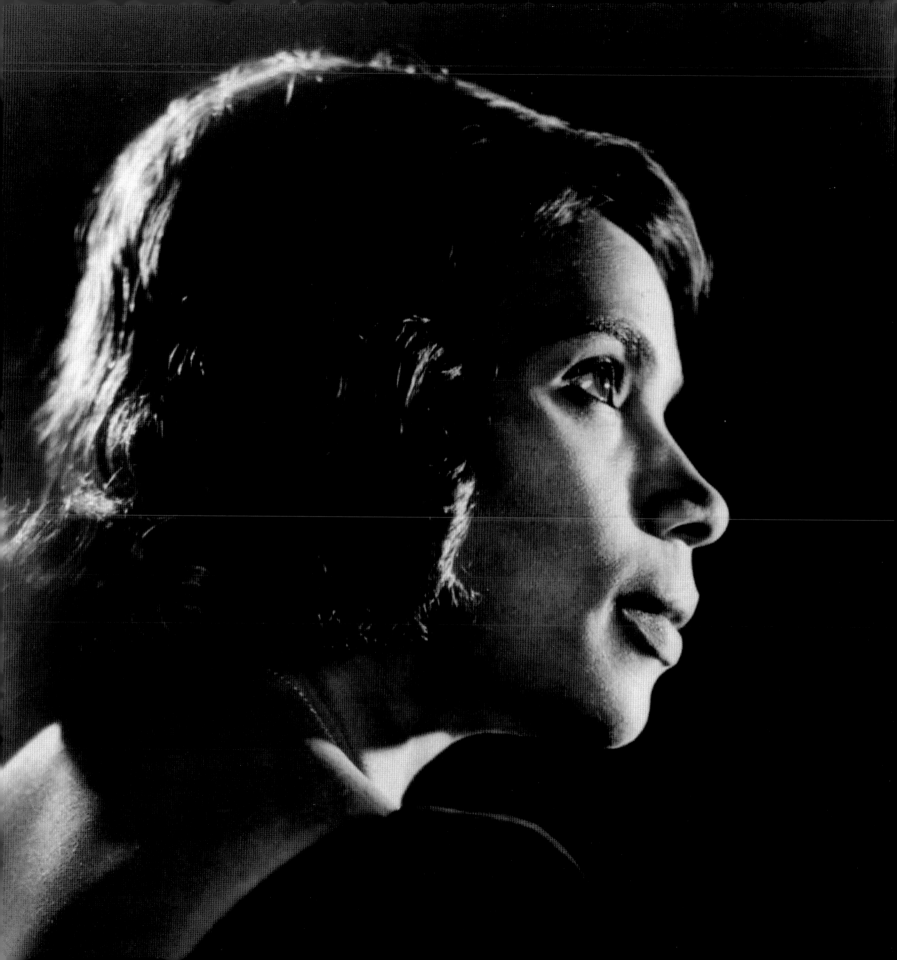

imogen cunningham

by MARGARETTA MITCHELL

WE SAW HER STRIDING around San Francisco, easily recognized by the beaded cap atop a fringe of white bangs and the black cape winging behind her intent little figure. The message she conveyed was hopeful and reassuring: that it was possible to grow old, working; to maintain interest in life; to be energetic; to be wholly oneself—in short, to love one's destiny....

From the very beginning, Imogen's approach to portraiture stressed her commitment to the human, rather than the heroic, quality of the subject. Her respect for differences among people would not let impressions be reduced to stereotypes; on the other hand, she rejected anything that made a man seem larger than life. With each sitter she always tried to penetrate the mask, to reach the person. Even in 1910, when she was a student in Germany, her portrait of Professor Luter was the result of his suggestion that he concentrate on a mathematical problem while she photographed: the snap of the shutter would reflect the moment of greatest mental intensity. That interaction gave her insight into a method of breaking through the self-consciousness of the sitter—a method which she continued to use, asking questions about the sitter's life and thoughts in order to obtain an expressive portrait. She said essentially the same thing, both in writing for her alumnae journal in 1913 at the beginning of her career and in her last interview, in the spring of 1976, about the requirements of fine portrait work: "You must be able to gain an understanding at short notice and at close range of the beauties of character, intellect, and spirit, so as to be able to draw out the best qualities and make them show in the face of the sitter." ... Although her career spanned over half the history of photography itself (her first exhibition was in 1912 at the Brooklyn Academy of Arts and Sciences), she was not well known beyond the West Coast until the 1960s. She was mainly recognized for her participation in the f/64 Group, composed of Bay Area photographers who, during the early thirties, championed the straight approach in contrast to the then-popular pictorial style....

She wore many hats, real and symbolic, including among them: cottage queen, comic-opera witch, hippy grandmother, curious child, researcher, gossip, intellectual, horticulturalist, gardener, cook, worker, comedienne, and, last but first, artist. While she was unpretentious as a person, Imogen was of a sophisticated intelligence, carrying a high standard of behavior, honesty, and integrity in work and life. Hers was a rare breed of a tough strain, a humanist with a sense of humor, one whose interests were as varied as her friends, and always growing. A photographer by trade and actress by nature, Imogen Cunningham could play all these roles; after all, she had spent ninety-three years acting them out, developing the parts to her person, creating at last this ageless, frisky, elfin creature, a crone in a black wool cloak, our heroine of the camera, bright-eyed, quick-witted, and working—even after ninety.

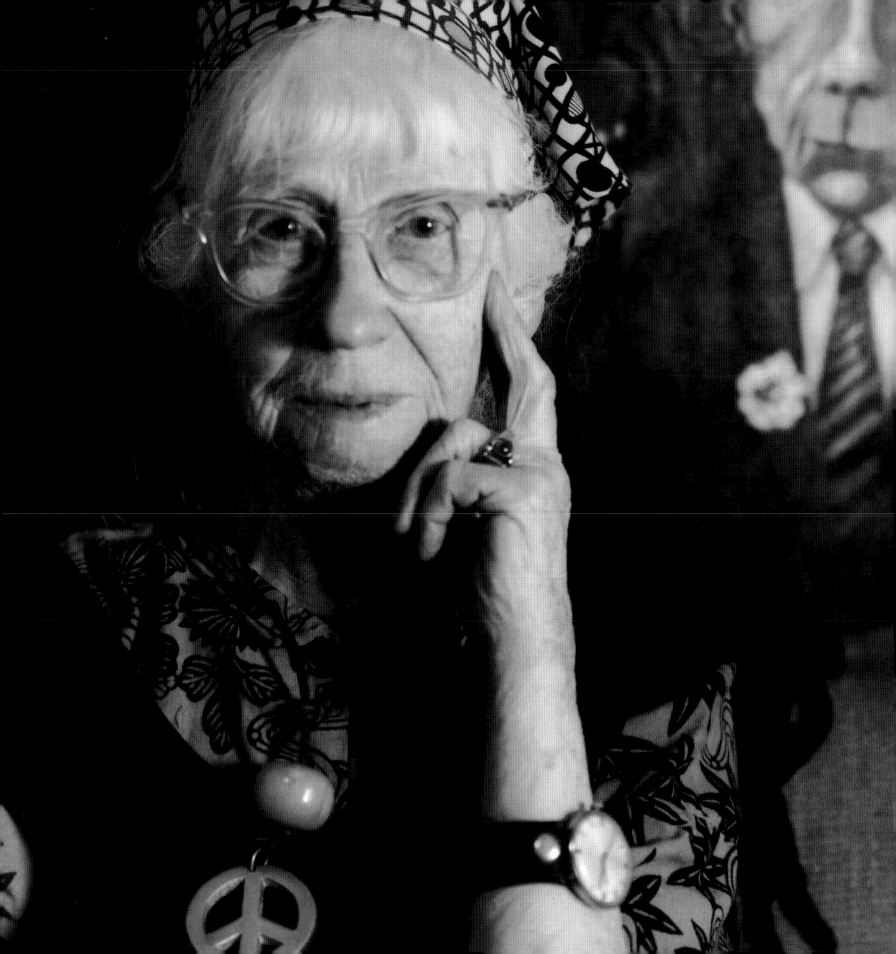

billie jean king

by SALLY JENKINS

EVERYTHING SHE HAS DONE seemed urgent. Billie Jean, the fireman's daughter, came at you with sirens blaring. On the tennis court she was a streak of blue-suede sneakers and sequined lapels, a flash of dressed-up muscle and discontent. Her aggressive serve-and-volley style was politically significant: When in doubt, she charged, and with that philosophy she shifted the spectrum of female possibilities from the decorative to the active and helped to Frankenstein a generation of women athletes.

Her first cause was to take tennis out of the country clubs and straight to the public, and she became a significant force in changing the culture of the sport from old-time elitism to modern professionalism. A sense of mission burgeoned in her as an amateur on the public courts of Long Beach, California, where she fought for equal consideration with the resort-bred players. She struggled through Los Angeles State College as a playground instructor while making Grand Slam finals. When she won her first Wimbledon singles title, in 1966, she received a 50-pound gift voucher good for buying tennis wear. Her only other compensation was a half-dozen Mars bars, which some of her fellow players left in her room by way of congratulations....

Then came the Pigs versus Libs debate. King's Battle of the Sexes victory over Bobby Riggs in 1973 was, despite its comical trappings, a triumph of sorts for the women's movement. The political and personal stakes were so high that night in Houston that the normally impervious King threw up in the locker room beforehand. More than 30,000 people flocked to the Astrodome, where they saw King, 29, borne in on a throne. Then she defeated the 55-year-old Riggs 6-4, 6-3, 6-3 in what was a precursor of today's made-for-television sports spectacles. The tennis was awful, but King's victory meant something. With it, insidious notions about the desire and ability of women to compete in the big time fell away. "Before that," King says with a touch of hyperbole, "women were chokers and spastics who couldn't take pressure. Except, of course, in childbirth."

So every time a little girl beats her brother in a game of pop-a-shot or a sorority girl plays flag football, you might credit King. There is little in the realm of sports for women that she did not help nurture. Among other things, she was a vocal advocate of establishing college athletic scholarships for women through Title IX legislation; she helped create the Women's Sports Foundation, a fund-raising organization for amateur athletes; and she helped found *Women Sports* magazine (now *Women's Sport & Fitness*), which shared her conviction that you did not need a male genetic imprint to read about athletics.

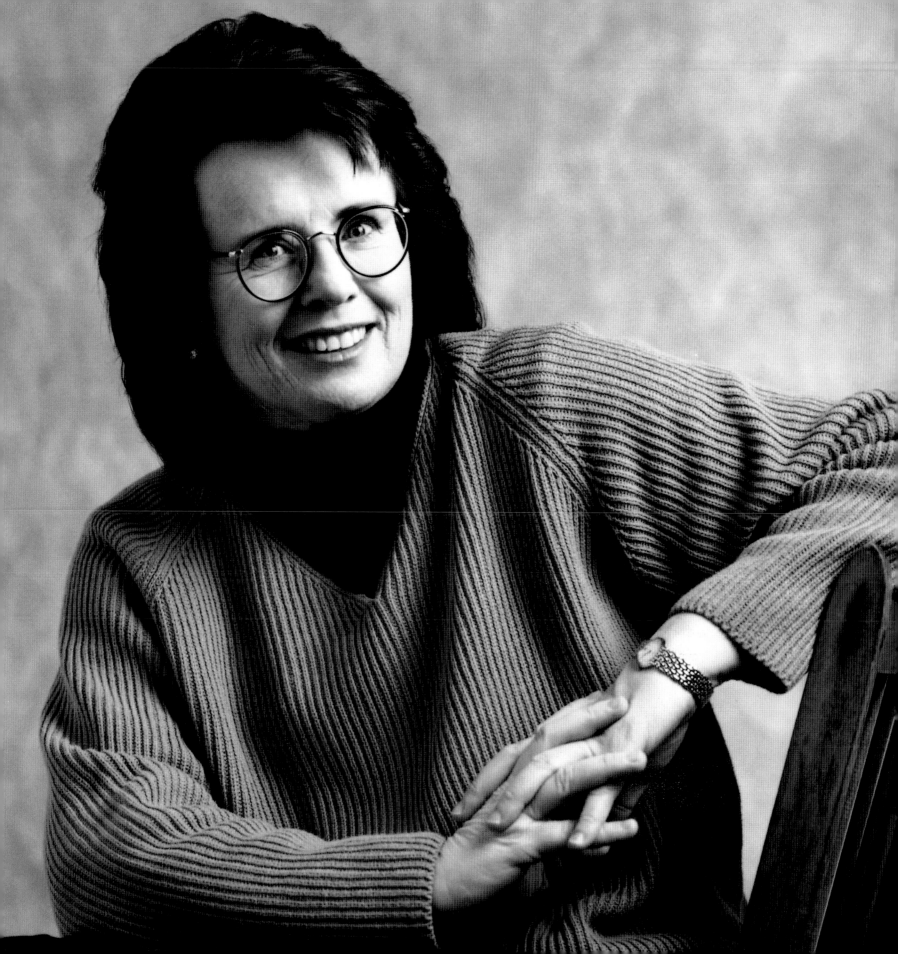

margaret thatcher

by BRENDA MADDOX

WOMEN, DO YOU WANT to lead your country without going the widowhood route? Study the progress of Margaret Thatcher. First, pick your political system with care. A British form of government, not so much a democracy as an elected dictatorship run by the party controlling Parliament, would suit you well. Once in power, use all those techniques formerly known as feminine "wiles." Flirt, weep, surround yourself, if that is your weakness, with good-looking men. Promote young ones to heights they never dreamed of reaching so soon; suppress the rise of colleagues nearer your age. Among European prime ministers, exploit the uniqueness of your sex....

Don't waste time on "women's issues." Do nothing to identify yourself with the special concerns of your own sex. Keep other women, with rare exceptions, out of high posts.

Think of Lady Macbeth. Unsex yourself. Wear battle dress at every opportunity. Do not spare a thought about "mothers' sons" when ordering men to war. But pity men for their weakness. Say things like, "This is no time to go all wobbly, George" to the American President with no sense of double-entendre....

Remember that image is all. Lower your voice to a husky baritone. Make yourself into what Roland Barthes called "a face object." Shudder at the photos of yourself starting out: mousy brown, permanent wave, sharp little teeth, uncertain gaze. Make that hair regally golden and wear it big, with never a strand out of place. Suffer agonies at the dentist to remake your smile. Get your supporters to give you important jewelry for your dark suits. Don't make jokes. Some people can tell 'em. You can't.

Speak slowly. Truth is simple. Running the economy is like running a household. The Germans are not to be trusted. There is no such thing as society. Hunger strikers are men who have chose to die; let them.

Above all, be utterly convinced that you alone can save your country. In moments of doubt, commune with the ghost of your father, a small-town grocer and politician. You owe all your principles to him.

Accept that you may become an object of derision in your own country, caricatured as a bouffant-haired tyrant in a pin-striped suit or a Nazi in jackboots, laughed at for simple remarks like, "Yes, we have become a grandmother" when your first grandchild is born. Feminists may dismiss you as an "honorary man," the royal family may mutter about your lack of compassion, but abroad you will be an honored guest, hailed as a forthright leader, a champion of NATO and a role model for women.

Your lasting image will exude the potency of both sexes. As François Mitterand put it, "Mrs. Thatcher has the eyes of Caligula and the mouth of Marilyn Monroe."

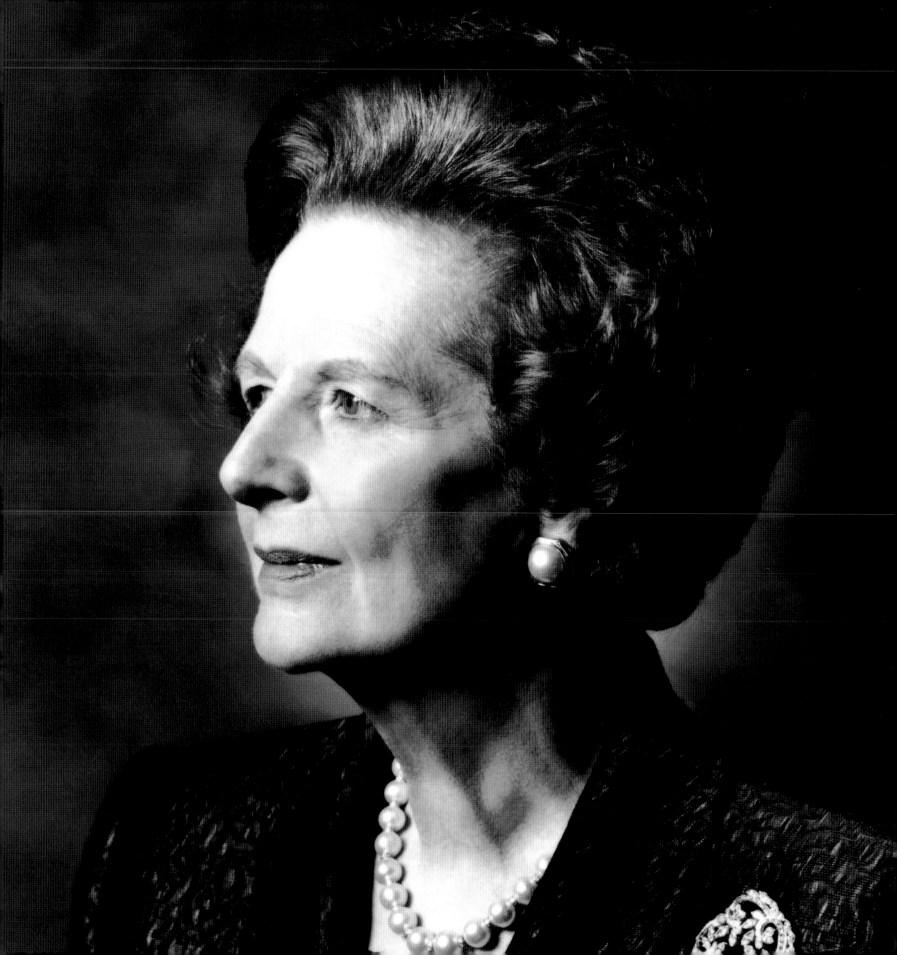

greta garbo

by ISABELLA ROSSELLINI

O F T H E S W E D E S who made it big in Hollywood, Garbo was the star of the silent movies era; my mother, Ingrid Bergman, was the star of the sound era. That's how the press classified them. When Mother first came to Hollywood, she immediately and politely sent Garbo some flowers and a note—she thought they could share some Swedish evenings: meatballs, aquavit, candles, and relaxed conversation in their native tongue. Garbo sent a telegram accepting the invitation, but not until three months later, just as Mother was about to leave town. Mother told George Cukor, who was a friend of Garbo's, about it and Cukor laughed. "Of course, Greta wouldn't have sent the telegram unless she was certain you were leaving."

Mother greatly admired Garbo, whose understated style of acting was the same as her own. They shared that kind of Swedish spare and spartan elegance, the purity and straightforwardness. One knows they didn't lie. But their mystery and vulnerability were blended differently: Mother had a great deal of the latter; Garbo was enigmatic, magnetic, and cool.

The only thing I remember Mother saying about Garbo, maybe because she often wondered about it, was: "She retired at 36. All those years afterward she got up in the morning with nothing to do. If you have children or grandchildren it's different, but she didn't have any. What can she possibly do all day?"

So I never met Garbo with Mother over a plate of Swedish meatballs. And when I think of her it's not as a real woman or even as an actress. Instead, I see a beautiful close-up with tears in her eyes, a man (I think) dying in her arms. I remember only Garbo's face, not what the tragic event was that caused her such desperation.

Garbo sticks in my brain as a series of stills. Cecil Beaton's, of course, but also frames from her movies. The way she walked in *Queen Christina*, for example: fast, dynamic, decisive, masculine—like a premonition of feminist attitudes to come.

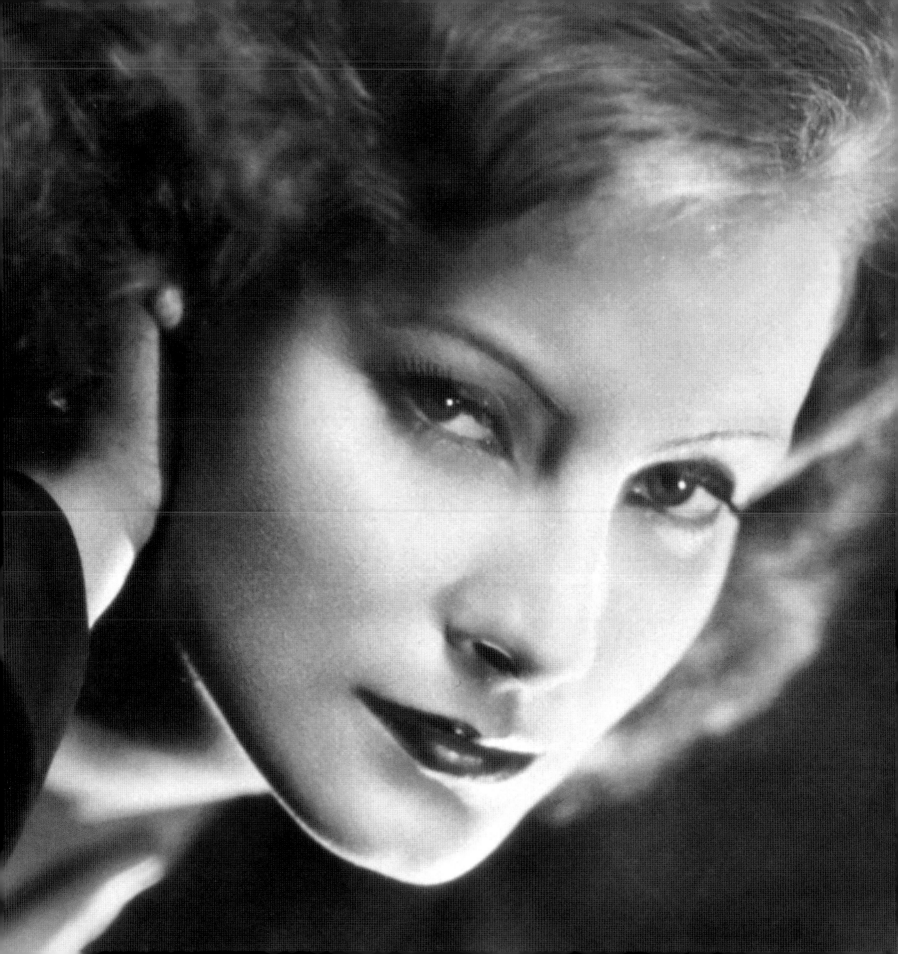

sister helen prejean

by BETSY WAGNER

WHEN SHE LEFT HOME in 1957 to join a New Orleans convent, Helen Prejean was a tender 18. She remembers standing in her Baton Rouge kitchen. Her trunk, stuffed with black and white clothes and a pair of "old lady shoes," was already in the car. Her composure and commitment to God were intact. Her mother asked her if she had fed Billy Boy, the yellow-and-green parakeet she had taught to recite half the "Hail Mary" prayer. "I leaned over and began to sob. I cried all the way to New Orleans. It was the parakeet that did me in"—reminding her that she faced a lifetime of seclusion, forbidden from visiting her childhood home again.

Fifteen years ago, her order opened its convent doors and sent the nuns—plain-clothed—into the community to work with the poor. Today, this self-proclaimed "child bride of Christ" is anything but secluded. In the past month, Sister Prejean, now 56, has been on *PrimeTime Live*, *Oprah*, and CBS's *Day & Date*. Colleges and groups across America send speaking invitations. Almost everyone, it seems, wants to hear about *Dead Man Walking*, her riveting 1993 book about the death penalty....

Since 1982, the real-life Sister Prejean has been the "spiritual adviser" to five men on death row at Louisiana's Angola prison; three were executed. She pushed all five to accept responsibility for their unspeakable crimes. Along the way, she offered a friendship of sorts, chatting with them about simple things outside the prison walls: the weather, new music, her book. In their final hours, she says, "I am love in the midst of hatred for them."

Her compassion often rankles families of murder victims, even those she tries to help. Recently, one victim's mother phoned her and protested that the movie "resurrected all of our grief again." After she hung up, Sister Prejean was "so shaken I had to put on a sweater. I only get that feeling of coldness in the death house. I just said, 'God, what have I done?' " ...

She long has worried that her work compounds the pain of the victims' families. When she sits with them and hears their cries for vengeance, she says, "I would love to give them that more than anything." But she cannot. "I don't believe in matching pain for pain and death for death," she explains, her voice firm. "It compounds the sorrow and the loss and the pain." So, instead, she fights against the death penalty in any way she can: in the courts, on television, in government offices.

Burl Cain, a strong backer of capital punishment when he became Angola's warden last year, has taken her words to heart. "I vacillate between whether I am for or against the death penalty," he reports. "She caused me to do a lot of soul-searching. She smiles at me a lot, like she knows of the struggle that is inside of me." She says she does, hoping that the warden—and everyone—will come to see the issue her way.

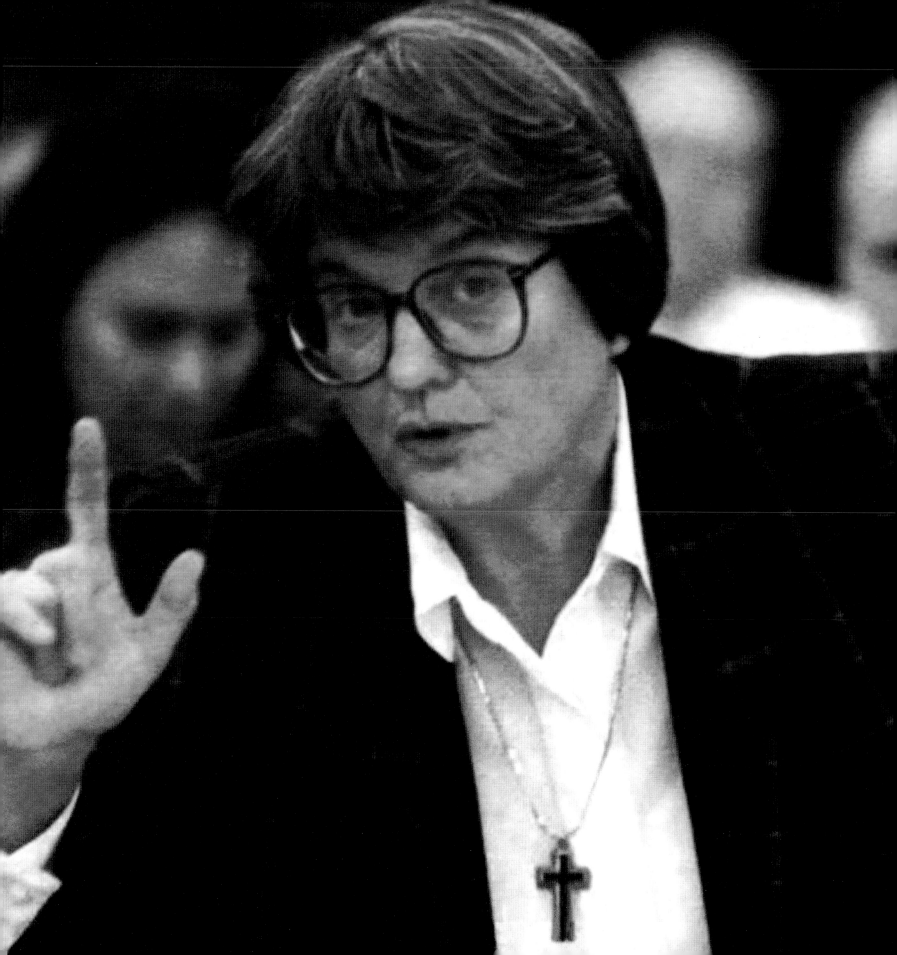

julia child

by KAREN LEHRMAN

IN THE 1950S, America was a meat-and-potatoes kind of country. Women did all of the cooking and got their recipes from ladies' magazine articles with titles like "The 10-Minute Meal and How to Make It." Meatloaf, liver and onions, corned beef hash—all were considered hearty and therefore healthy and therefore delicious. For many women, preparing meals was not a joy but a requirement, like cleaning toilets and having (male-centered) sex. Food was fuel; it merely satisfied a need....

Enter Julia Child. In 1961, a 49-year-old housewife with negligible formal training in cooking published a sophisticated guide to the basic principles, techniques, and recipes of classic French cuisine, titled *Mastering the Art of French Cooking.* The first hardcover edition sold 650,000 copies, starting a minor revolution in an American culture still reveling in the convenience of canned soups, frozen vegetables, and TV dinners. Two years after *Mastering,* Julia Child took her message to an even wider public with *The French Chef,* broadcast on National Educational Television, the precursor to the Public Broadcasting System. For dinner tables across the country, the program ended the reign of liver and onions—first for the aspiring professional classes and ultimately for much of America. Affluent women clamored to take cooking classes; gourmet "specialty" stores like Williams-Sonoma (founded in 1963) cropped up at the local shopping center and, later, the mall; and three-star restaurants began to sprout in large cities.

Yet Julia Child did more than change the way Americans relate to food. She also changed the way Americans relate to women. Betty Friedan may have identified the feminine mystique, but Julia Child—with her ungainly height (6 feet, 2 inches), late marriage, gracelessness, childlessness, wit, and meteoric rise in the traditionally male preserve of professional cooking—showed that women could turn the mystique on its head. More important, she did so without declaring herself a victim of men, society, or the more pleasurable aspects of traditional femininity. Indeed, just as feminists of the day were exhorting women to get out of the kitchen, she was welcoming women—and men—back to an enlightened kitchen, a kitchen-cum-art studio. And while men wouldn't come on board for another couple of decades, many an overeducated housewife grasped at the opportunity to empower herself through cooking.

margaret bourke-white

by VICKI GOLDBERG

MARGARET BOURKE-WHITE became a historic figure while she was still making history. Her name, face, and photographs were known to millions, Hollywood made movies loosely based on her exploits, Edward R. Murrow interviewed her on *Person to Person*. A pioneer, she always seemed to be first: the first one to do it, and then first in her field. She dared to become an industrial photographer and a photojournalist at a time when men thought they had exclusive rights to those titles, then rose with startling speed to the top of both professions. In 1930, she was the first photographer for *Fortune* magazine; six years later, she took the cover photograph and lead story for the first issue of *Life* magazine. *U.S. Camera* proclaimed that "strange indeed is the fate that has chosen a woman to be the most famous on-the-spot reporter the world over."

Women everywhere regarded Bourke-White as their ideal. From 1936, when she was named one of the ten outstanding American women, to 1965, when she was chosen as one of the top ten living American women of the twentieth century, she was constantly in the public eye as a woman of achievement.

Her adventures and her derring-do were breathtaking. Camera in hand, she galloped on horseback across Russia, climbed onto an ornamental gargoyle sixty-one stories above a New York sidewalk, survived a torpedo attack, and accompanied a major bombing mission in World War II. She was a true American heroine, larger than life—perhaps even larger than *Life*.

If she had an outsize career, she had an outsize personality as well. People had an astonishing range of reactions to her, as if she were some sort of magnetic force that alternately attracted and repelled. There are those who remember an impossibly arrogant woman, wholly self-centered, utterly unfeeling. Some of her colleagues thought her manipulative but so charming and so hugely talented that it did not really matter. Friends and lovers merely recall her as magnificent. They never met anyone like her, they say, and it sounds like the truth—no one so enthusiastic, so strong, so endlessly attentive, so extraordinarily courageous. The one response no one ever registered to Margaret Bourke-White was indifference....

The evidence also makes clear that Margaret Bourke-White carefully molded her public image, constructing an attractive, subtly misleading myth about herself as a photographer. The unadorned facts would have sufficed for a contemporary fable, but her success was more deliberately planned and more becomingly polished than the ordinary kind. In the end, when she faced a tragic, incurable illness, her spirit shone so brightly that it alone eclipsed any myth she could ever have invented.

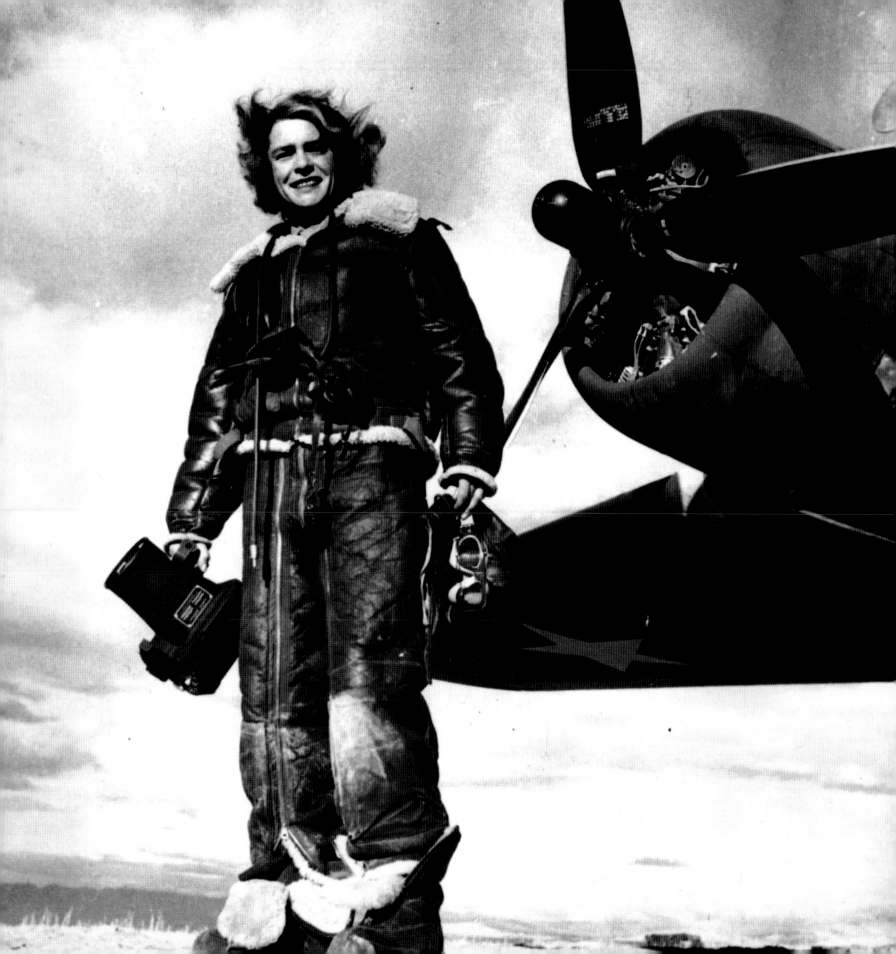

marian wright edelman

by RICHETTE L. HAYWOOD

MARIAN WRIGHT EDELMAN lives in the eye of the storm. Struggling to guide the winds of change. Struggling to make a difference. Motivated by one thing: an insatiable desire to leave this place called America better than the way she found it. Not necessarily for herself, though that would be a fair exchange, but for the children. Children whose voices so often go unheard by adults and whose cries drive this preacher's daughter to places most of us could not imagine.

"I would never do anything else," says Edelman from her eighth-floor office in the Children's Defense Fund, the Washington, D.C.–based child advocacy organization she founded in 1973 and, without government aid, transformed into the nation's No. 1 child advocacy organization. "I'm doing what I think I was put on this earth to do. And I'm really grateful to have something that I'm passionate about and that I think is profoundly important."

Hers is not powertown rhetoric. Washingtonspeak political mumbo jumbo. You can tell by the fire in the eyes. The fire is the reason she has been embraced as America's First Mom by everyone, across the board, no matter the color, and it's why she is considered the country's most effective child advocate. When she speaks about children, Edelman's eyes burn with the fervor of a woman—a wife and mother of three grown sons—who sees what she calls the gravest assault on the rights of children in 50 years, and she is driven to stop it....

"As tough as times are and as hard as families are struggling for children, each and every one of us can do better," says Edelman. "The call is to everybody," says Edelman. "Parents, grandparents, community and religious leaders ... It's time to come and stand together across race, class, faith and region, and say we may not be able to agree on a lot of things, but we're going to agree on not doing harm to kids, and we're going to provide them with what they need." ...

With those comments, the mother, the wife, the preacher's daughter, and the national leader distills the essence of her appeal. Intelligent but not insolent, religious but not self-righteous. She knows the world isn't fair— not in Washington, D.C., or anywhere else. That is why Edelman has spend her adult life doing what she can to tip the scales in children's favor. "I just believe very deeply in what I do," says Edelman, who is mystified by "all those folks who say they believe in the Lord but are scared to speak truth. Why are we so scared to fight about things? We need to struggle and we need to teach our children how to struggle.... Life is not about easiness. Life is about trials, struggles, learning to share, and leaving something better than what you found."

eleanor roosevelt

by BLANCHE WIESEN COOK

WE KNEW THAT SHE was the First Lady of the World. We knew that she cared for the poor, the homeless, and the hungry. We know that for 12 years she was America's most active and inspiring First Lady. We knew that she was honest, courageous, and bold. We knew about her dignity under duress and her capacity for endless hours of hard work. On such still controversial issues as racial justice, economic security, and international peace, her vision was like a beacon. We recognized the truth in her friend Adlai Stevenson's memorial: "Her life was restless, crowded, and fearless." But still we did not claim her as a feminist hero? Why? ...

As First Lady, ER worked earnestly for the advancement of women. On Lorena Hickok's advice [reporter for the Associated Press], ER decided to hold weekly press conferences for women only. A boon to the women's press corps, this decision required that every major newspaper and journal, and every press syndicate hire a woman reporter. She was responsible for the fact that women were appointed to administrative agencies at every level of management in unprecedented numbers....

For 40 years ER took the lead on most of the issues of her day. She championed civil rights before any other Administration official, and frequently despite FDR's opposition. Her personal friendship with Mary McLeod Bethune, founder of the National Council of Negro Women, and NAACP leader Walter White helped to shape her views and her politics. Outraged by injustice, ER's style was personal and direct. During the 1939 meeting that inaugurated the Southern Conference on Human Welfare in Birmingham, Alabama, ER placed her own chair in the aisle in the middle of the segregated sections, launching a silent protest—that was considered shocking and outrageous at the time—against America's "race etiquette." ...

To her death on November 7, 1962, ER remained an individualist, and a maverick. She was able to do what she did because of her understanding of community and alliances. She understood that political activity was not an isolated individualist adventure. She appreciated the feminist networks of love and support that she created and carefully nurtured. She was loyal to her friends, and they were loyal to her. Together they worked tirelessly for the advancement of women and a life of decency for all people.

A great-hearted woman with a wealth of compassion and a gift for love, ER awakened the conscience and the spirit of everyone she touched with her passionate creed: "One must never turn one's back on life. There is so much to do, so many engrossing challenges, so many heartbreaking and pressing needs."

princess diana

by FRANCINE DU PLESSIX GRAY

ONE OF THE PARADOXES of the Princess of Wales's death is the impact that it has had on those of us who paid minimal attention to her, who have an élitist disdain for the cult of celebrity, and who use ice tongs to carry copies of *People* to the trash can. I've talked to many women of that kind in the past three days—storekeepers, a hairdresser, a psychiatrist, a left-leaning political activist, a professor of philosophy, all of us over fifty—and found that their reaction to last weekend's events was very similar to mine.

All Sunday and Monday, women friends called. We discussed the sadness of it, and why we were so upset, we veterans of the causes of the sixties and seventies, we snooty star-bashers who had been dismayed by much about Diana's life—the glitzy clothes, the shallow glamour of her social set, the appalling sums spent on self-improvement therapies. As "progressive" feminists, we'd lumped her and her friends into a world that for years we'd arrogantly scorned, and yet we were bawling.

Gradually, a pattern emerged—a configuration to our sadness. Diana expressed, more poignantly than almost any other woman of our time, the melancholy solitude specific to many women's experience of marriage. The disappointments, the humiliations of her experiences with men reflected the rage my friends and I still felt, decades later, toward all those fellows in our own pasts who had jilted or deceived us, the cads who had moved on to exploit others, deaf to our anxieties and quests.

What else have we talked about when we talked about Di? About her uncanny knack for exposing privileged society's callowness—for informing us that what she'd found at the top was even worse than we'd suspected, was marked by meanness, hypocrisy, cynicism, and, above all, by a stupendous deafness to a very shy, vulnerable young woman's psychic growing pains. About the bizarreness of an institution—monarchy—that, though it has lost all true power, remains part business corporation, part public-relations firm, part pedigree kennel: Play our game or we'll fire you; keep our image squeaky-clean; be a good breeder. We know what Diana went through when she had fulfilled all those orders—the glacial manner in which she was pushed aside after she had served the royal purpose. All too many women have suffered some modest, plebeian measure of her heartbreaks. Apparently, it took her death for some of us to realize the accuracy of her message.

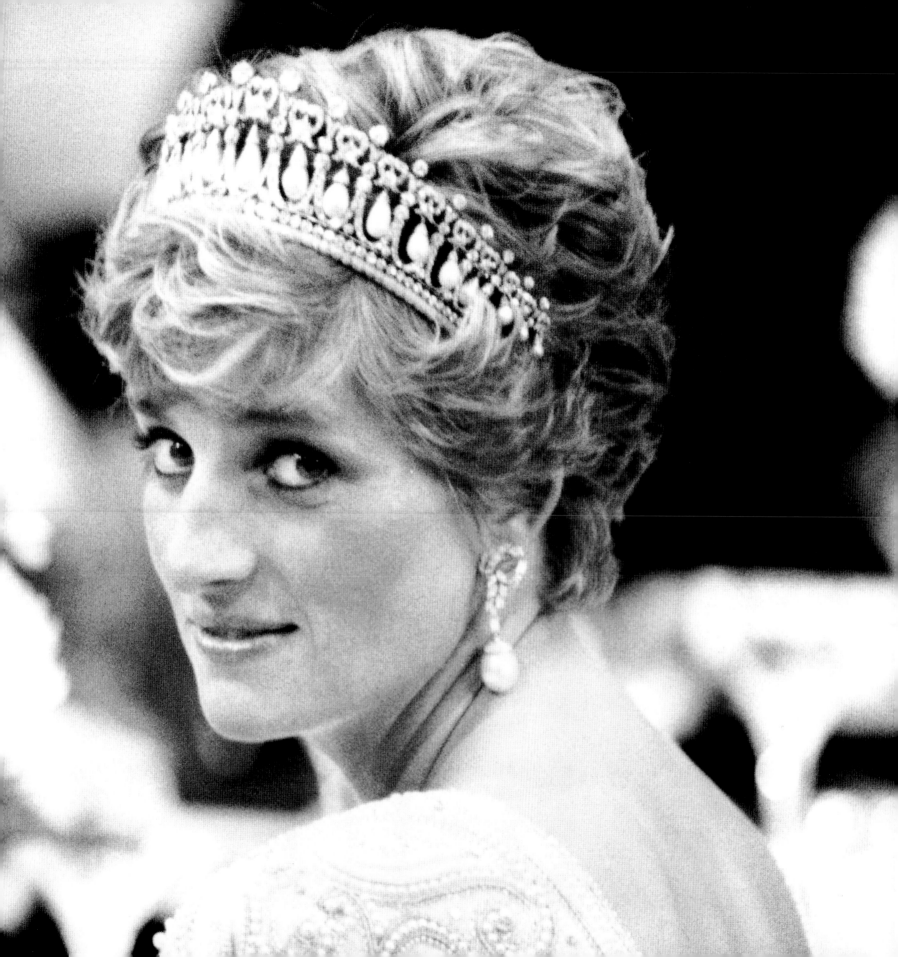

biographies

 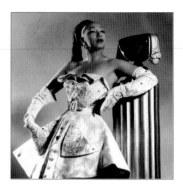

marian anderson
(1897–1993) was born in Philadelphia and grew up singing in her church choir. In the 1930s she traveled widely, finding acclaim as perhaps the greatest living contralto of the time. In 1955, Anderson became the first African American to appear at the Metropolitan Opera. She received the Presidential Medal of Freedom in 1963.

jessye norman
is a renowned opera and concert singer with a repertoire ranging from Mozart to African-American spirituals.

Photo: ARCHIVE PHOTOS

page 90

aung san suu kyi
is a Burmese political leader who has served time under house arrest for her non-violent campaign to return democracy to her native country. In 1991, she was the eighth woman in history to receive the Nobel Peace Prize, which because of her confinement she was unable to accept.

gayle kirshenbaum
is a writer based in New York City; she writes regularly for *Ms.*

Photo: ROBIN MOYER

page 74

joan baez
left Boston University to sing in coffee houses. She was discovered and gave a groundshaking performance at the Newport Folk Festival in 1959. Adding protest songs to a repertory of traditional folk ballads, she became a leading voice of the 1960s. Today, Baez performs numerous benefits for world peace.

himilce novas
has written several fiction and nonfiction books about Latino culture.

Photo: MICHAEL COLLOPY

page 78

josephine baker
(1906–1975) was born in St. Louis. At age 13, she left home to travel with vaudeville. She worked on Broadway and at Harlem's Plantation Club before leaving for France in 1925, where her scanty costume, lively dancing, scat singing, and outrageous behavior earned her an international reputation. Throughout her life, Baker worked for racial equality in America by insisting on integration in theaters and nightclubs.

meg cohen
is a regular contributor to *Harper's Bazaar.*

Photo: CORBIS-BETTMANN

page 40

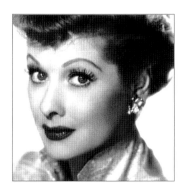

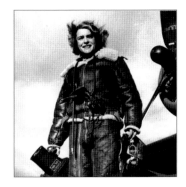

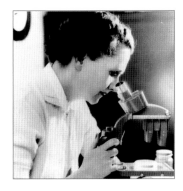

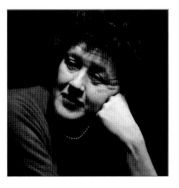

lucille ball
(1910–1989) worked as a model, movie actress, and radio personality before embarking on the legendary situation comedy *I Love Lucy*. Her near-perfect timing and genius for sight gags allowed her to star in two other successful shows, *The Lucy Show* and *Here's Lucy*. She continued to appear on television specials until her death in 1989.

linda martin
has written books on the entertainment industry, including *Women in Comedy*.

Photo: ARCHIVE PHOTOS

page 38

margaret bourke-white
(1904–1971) was staff photographer for *Life* magazine between 1936 and 1969. Photographing Nazi camp survivors and such world leaders as Mahatma Gandhi, she became the premier photojournalist of her time, paving the way for other women to enter the profession.

vicki goldberg
is a photographer who writes books and essays on her field.

Photo: CORBIS-BETTMANN

page 104

rachel carson
(1907–1964) was a marine biologist and naturalist whose writings helped to shape America's growing environmental consciousness. Her research during the 1950s on the effects of pesticides on the food chain was published in *Silent Spring*, her most influential work, which led to the banning of the DDT.

terry tempest williams
is a naturalist and writer. Her books include *An Unspoken Hunger* and *Refuge*.

Photo: CORBIS-BETTMANN

page 28

julia child
was born in Pasadena, Calif. After training at Le Cordon Bleu in Paris, she coauthored the two-volume *Mastering the Art of French Cooking* and hosted several popular television cooking shows, which established her as one of the most successful celebrity chefs in the country. Her other books include the recent *The Way to Cook*.

karen lehrman,
author of *The Lipstick Proviso: Sex and Power in the Real World*, is editor of the online magazine *Civnet*.

Photo: PAUL CHILD

page 102

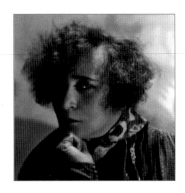

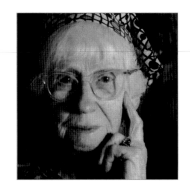

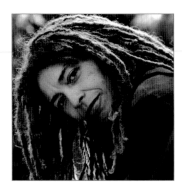

colette

(1873–1954) was a French author of novels, plays, short stories, and screenplays. Her works are said to have the magical effect of capturing the essence of France, making her one of the country's most beloved writers. She also appeared regularly in music halls as a dancer and mime.

yvonne mitchell

is a distinguished stage, screen, and television actress and author of numerous novels, plays, and children's stories.

Photo: CECIL BEATON

page 36

imogen cunningham

(1883–1976) studied chemistry and photographic chemistry in Dresden, Germany, before starting her own commercial portrait studio. She moved to San Francisco in 1917 and helped found an innovative movement of photographers known as Group f/64. Cunningham is most admired for her sharply focused black and white portraits and nature studies.

margaretta mitchell

is a photographer and writer. She is the author of *Gift of Place* and, with Dorthea Lange, *To a Cabin*.

Photo: IMOGEN CUNNINGHAM

page 92

angela davis

was educated at the Sorbonne in France and Brandeis University. She became a controversial activist because of her intimate involvement with the Black Panthers and the Communist Party. Davis went on to become a prominent lecturer and professor. She currently teaches at UC Santa Cruz and serves on the National Political Caucus of Black Women and the National Black Women's Health Project.

kathleen thompson

writes regularly for *The New Yorker*.

Photo: BRIAN LANKER

page 70

bette davis

(1908–1989) made her Hollywood debut in 1931 with *Bad Sister*. Between 1935 and 1946, she was a prime box office attraction and was nominated for ten Oscars; she won two, for *Dangerous* (1935) and *Jezebel* (1938). Throughout her career, Davis was known as an independent woman who would fight the studios for the best parts. She usually won.

janet flanner

wrote for *The New Yorker* for decades as Paris correspondent and cultural commentator.

Photo: ARCHIVE PHOTOS

page 46

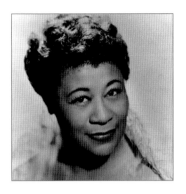

princess diana
of Wales (1961–1997)
was born in Sandringham,
Norfolk. She taught kinder-
garten before marrying Prince
Charles. Her dramatic divorce
from Charles changed the
existing royalty laws. Before
her tragic death in a Paris
car crash, Diana worked for
children's causes, AIDS, and
held an advisory role with the
International Red Cross.

francine du plessix gray
writes for *The New Yorker*.
She has also published a novel,
World without End, as well as
several volumes of nonfiction.

Photo: CORBIS-BETTMANN

page 110

amelia earhart
(1897–1937) became the
first woman to fly across the
Atlantic in 1928. Her subse-
quent 1932 solo flight set the
transatlantic record flying
time at 14 hours and 56 min-
utes. In the following years,
Earhart continued to break
her own records, becoming a
favorite of the American
public. In 1937, she set off
on an equatorial trip, but
shortly after takeoff ceased
communication and disap-
peared. Innumerable searches
revealed nothing.

camille paglia
is a professor at the University
of the Arts in Philadelphia.
She is the author of *Sexual
Personae* and *Vamps and Tramps*.

Photo: SUPERSTOCK

page 12

marian wright edelman
has worked as an attorney for
the NAACP and founded the
Washington Research Project,
a public interest law firm. She
currently focuses her efforts
on the Children's Defense
Fund, where she lobbies as
its founder and president for
children's rights in education
and health care.

richette l. haywood
is a regular contributor to
Ebony and *Jet*.

Photo: MICHAEL COLLOPY

page 106

ella fitzgerald
(1918–1996) was discovered
at an amateur show in 1934.
She almost singlehandedly
invented scat singing and
helped establish the popular
standard as an art form. Over
several decades, "the First
Lady of Song" became one
of America's most celebrated
and influential jazz vocalists.

margo jefferson
is a cultural critic for the
New York Times.

Photo: CORBIS-BETTMANN

page 52

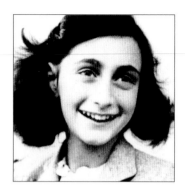

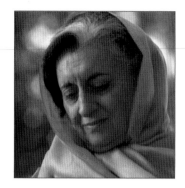

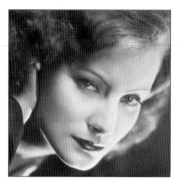

anne frank
(1929–1945) was a concentration camp victim who became a symbol of suffering under the Nazis. While hiding in a back room in Amsterdam from 1942 to 1944, she wrote her famous diary. Shortly thereafter, Frank died in the Bergen-Belsen concentration camp. Dozens of schools and villages for refugee children throughout western Europe are named after her.

liv ullman
is an internationally renowned actress who has portrayed Anne Frank on stage.

Photo: SUPERSTOCK

page 88

indira gandhi
(1917–1984) was the daughter of Nehru, India's first prime minister. In 1966, she became the country's first female prime minister. Gandhi dedicated herself to literacy and the betterment of the country, but her administration was also given to suppression and numerous states of emergency. In 1984, during a suppression of rebels, she was shot to death by Sikh members of her security guard.

s. susan jane
holds a doctorate in political science from the University of Hawaii. She works with the International Conference on Women and Power.

Photo: DILIP MEHTA

page 86

greta garbo
(1905–1990) was born in Stockholm, Sweden. In 1924, she moved to Hollywood and quickly became known as "the Swedish sphinx," a reflection of her aloofness and cool beauty. As an international star for MGM, Garbo personified all that was alluring, yet unattainable, about movie actors. She received a special Oscar in 1954.

isabella rossellini,
daughter of the actress Ingrid Bergman and director Roberto Rossellini, is an actress and model.

Photo: ARCHIVE PHOTOS

page 98

jane goodall
is an English primatologist and conservationist whose research has revolutionized our understanding of chimpanzee behavior. She worked in Kenya with anthropologist Louis Leakey and set up the Gombe Wildlife Research Center in Tanzania, which has studied the behavior of chimpanzees in their natural habitat for over thirty years.

virginia morrell
contributes regularly to *Science.*

Photo: MICHAEL COLLOPY

page 66

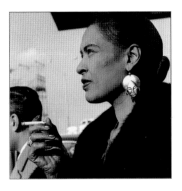

katharine graham
became president of a communications empire after her husband's suicide. As publisher of the flagship *Washington Post*, Graham established the paper's reputation through a strong emphasis on investigative journalism, including the breaking of the Watergate scandal.

mary rowland
is a contributing editor at *Working Woman*.

Photo: LIZZIE HIMMEL

page 84

martha graham
(1893–1991) was prevented from studying dance as a child. This did not stop her from becoming the most renowned modern dancer and choreographer in America. Graham was as famous for her demanding and autocratic personality as for the development of a radically innovative choreography, which employed spare, angular movements and exotic costumes.

alma guillermoprieto
is a staff writer for *The New Yorker*. She has also written the book *The Heart That Bleeds: Latin America Now*.

Photo: YOUSUF KARSH

page 34

audrey hepburn
(1929–1993) was a Belgian-born actress who is known for her classic film roles in the 1950s and 1960s, such as *The Nun's Story*, *Breakfast at Tiffany's*, and *Roman Holiday*, for which she won an Oscar. During her last years, she traveled as goodwill ambassador for UNICEF.

diane johnson
has written for numerous publications, including *The New York Review of Books* and *Vogue*. She has also published a novel, *Le Divorce*.

Photo: CECIL BEATON

page 20

billie holiday
(1915–1959) was one of the most influential singers in jazz history. She worked regularly with Count Basie and made dozens of classic small-group recordings between 1933 and 1942. Despite the beginnings of voice deterioration in the 1940s, she became more popular than ever and continued to perform, record, and appear in films. Her autobiography, *Lady Sings the Blues*, reveals her as a tragic figure battered by drug addiction and racial injustice.

elizabeth hardwick
is a well-known essayist and literary critic. She contributes to *The New York Review of Books*.

Photo: JEAN PIERRE LELOIR

page 14

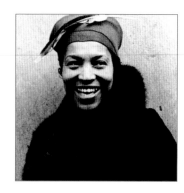

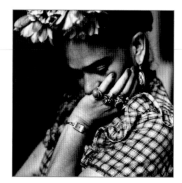

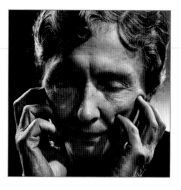

zora neale hurston
(1903–1960) was an author, folklorist, and anthropologist who studied at Howard University, Barnard College, and Columbia University. Best known for *Their Eyes Were Watching God*, a brilliant fictional mix of autobiography and folklore, Hurston influenced writers from Ralph Ellison to Toni Morrison. Though she died penniless and nearly forgotten, her works were rediscovered and brought back to print in the 1970s.

alice walker
has written numerous short stories and novels. She received a Pulitzer Prize and the American Book Award for her novel *The Color Purple*.

Photo: CARL VAN VECHTEN

page 24

frida kahlo
(1907–1954) was born in Coyoacan, Mexico City. After sending her work to be reviewed by Diego Rivera, she met and eventually married the painter. Kahlo's shocking, vibrant paintings depicted themes of pain and the suffering of women. A museum in her honor opened in Coyoacan in 1958.

guadalupe rivera,
the daughter of the painter Diego Rivera, was born in Mexico City. A professor of law, she is the author of law books and two books about her father.

Photo: CORBIS-BETTMANN

page 44

helen keller
(1880–1968), blind and deaf at nineteen months, was taught to speak, read, and write by teacher Anne Sullivan. As a child, Keller was an international celebrity; she went on to become an inspirational writer and lecturer. In addition, Keller promoted socialism, women's suffrage, and raised funds for the American Foundation for the Blind.

mary jo salter
is the author of numerous volumes of poetry and fiction. She is an editor of the latest *Norton Anthology of Poetry*.

Photo: YOUSUF KARSH

page 18

billie jean king
is an American tennis player whose domination of women's singles and doubles tennis for over fifteen years elevated the status of the game. She founded *Women's Sports* magazine in 1974 and is one of the founders of the Women's Tennis Association. In addition, King is a television commentator and author.

sally jenkins
is a regular contributor to *Sports Illustrated.*

Photo: CORBIS-BETTMANN

page 94

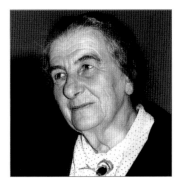

lynn margulis

is a cell biologist who has taught and performed research at the University of Massachusetts, where she was a distinguished professor. Margulis is a proponent of the controversial *Gaia* hypothesis, which views earth as a homeostatic system that is influenced by the actions of all living organisms.

elizabeth royte

writes about the natural world for numerous publications, including *Harper's Magazine*, *Outside*, and the *New York Times*.

Photo: RICHARD HOWARD

page 42

beryl markham

(1902–1986) moved to East Africa as a child, where she learned Swahili and Masai. She became an aviator, carrying mail, passengers, and supplies in her small plane to remote corners of Africa from 1931 to 1936, when she completed the first east-west transatlantic solo flight. Her autobiography, *West with the Night* (1942), contains her reflections on Africa and flying.

diane ackerman

has written several books, including the bestseller *A Natural History of the Senses* and *A Natural History of Love*.

Photo: CORBIS-BETTMANN

page 82

mary mccarthy

(1912–1989) graduated from Vassar College and began her career as a reviewer for *The Nation*, *The New Republic*, and the *Partisan Review*. Eventually, McCarthy found her niche satirizing American intellectual life in fiction. In her lifetime, she often engaged writers in public feuds and routinely took contentious political and literary stands.

cathleen mcguigan

is a literary editor at *Newsweek*.

Photo: CORBIS-BETTMANN

page 76

golda meir

(1898–1978) was one of the twenty-five signers of Israel's Proclamation of Independence and served as prime minister of Israel in 1969. She was forced to turn the government over after a surprise Syrian and Egyptian attack on Israel in 1973, but Meir continued to speak, raise money, and meet with world leaders until her death at age eighty.

judy gitenstein

is an editor and writer of children's books.

Photo: CORBIS-BETTMANN

page 58

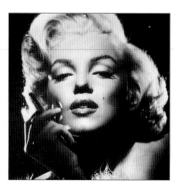 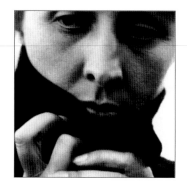 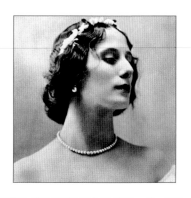

marilyn monroe
(1926–1962) grew up in a series of foster homes and orphanages. In 1946, she moved to Hollywood and landed a role as a breathy, sexy blonde in *The Asphalt Jungle*. After studying at the Strasberg Actors Studio, she gave more complicated performances in *Some Like It Hot* and *Bus Stop*. Monroe was married to both Joe DiMaggio and playwright Arthur Miller. She died in 1962.

gloria steinem, founder of *Ms.* magazine, was editor there until 1987. She has published several books, including *Marilyn*.

page 26

georgia o'keeffe
(1887–1986) studied at the Art Institute of Chicago and the Art Students League in New York. After graduating, she married photographer Alfred Stieglitz and began a series of now famous flower paintings. In 1946, she moved to the New Mexico desert, where for years she created stark, abstract landscape paintings.

joan didion
is the author of such classics as *Slouching Towards Bethlehem*, *Salvador*, and *The White Album*.

page 16

jacqueline onassis
(1929–1994) was born in Southampton, New York. She worked as a photographer before marrying John F. Kennedy in 1953 and becoming the most famous first lady in the history of the country. Her influence on fashion and style in the early 1960s is hard to overestimate. After Kennedy's death, she married millionaire Aristotle Onassis and eventually joined Doubleday, where she worked as an editor.

marilyn johnson
writes for *Life*, *Esquire*, and *Elle*.

page 50

anna pavlova
(1882–1931) was a Russian dancer who became a legend in ballet history. A prima ballerina with the Imperial Ballet by 1906, she started her own company and was best known for her *Giselle* interpretation. Pavlova's extraordinary grace and poetic movement helped create the ballerina image that persists today.

allegra kent
is the author of the autobiography *Once a Dancer*.

page 48

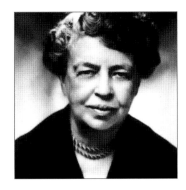

sister helen prejean, after teaching English at a girl's school, joined a New Orleans convent that sent plainclothes nuns into the community to work with the poor. Sister Prejean became spiritual advisor to several men on death row in Louisiana's Angola prison. Her astonishing book about her experiences, *Dead Man Walking*, was turned into a film by Tim Robbins in 1996. She continues to devote her time to fighting the death penalty.

betsy wagner writes for *U.S. News & World Report*.

Photo: SEANA O'SULLIVAN

page 100

eleanor roosevelt (1884–1962) emerged as a very public first lady by promoting causes that helped women, children, and the poor. Eventually she became a delegate to the U.N. General Assembly and chairperson of the U.N.'s Human Rights Commission. The most active and influential of all the president's wives, she became known as "first lady of the world."

blanche wiesen cook is author of several books, including a 1990 biography of Eleanor Roosevelt.

Photo: SUPERSTOCK

page 108

susan sontag is an internationally known essayist, critic, novelist, screenwriter, polemicist, activist, and film and theater director. With degrees from the University of Chicago and Harvard, she is best known for her critical essays and cultural analyses such as *Against Interpretation, On Photography*, and *Illness as Metaphor*.

larissa macfarquhar has been an editor at *The Paris Review* and *Lingua Franca*. She writes for *The Nation* and *The New York Review of Books*.

Photo: ANNIE LEIBOVITZ

page 22

gertrude stein (1874–1946) was a writer of poetry, fiction, and nonfiction, but is most acclaimed as an art patron with her lifelong companion, Alice B. Toklas. Stein and Toklas collected postimpressionist paintings and established a famous literary salon in Paris, where Picasso was the most common visitor.

cynthia ozick has written several novels and collections of short stories. She is most recently the author of the novel *The Puttermesser Papers*.

Photo: CECIL BEATON

page 54

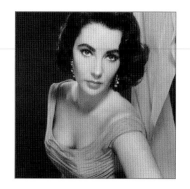

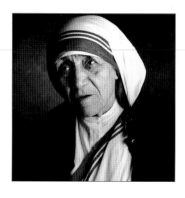

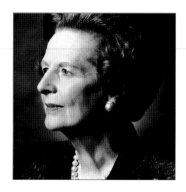

martha stewart
is a former model who has achieved amazing success with her homemaker's style magazine, *Martha Stewart Living*. Her equally popular television show features tips on cooking, gardening, and crafts.

patricia mclaughlin
is a writer for the *Philadelphia Inquirer*'s Sunday magazine.

Photo: JIM SPELLMAN/CORBIS

page 72

elizabeth taylor
made her screen debut in 1942 with *There's One Born Every Minute* and went on to win Oscars for her performances in *Butterfield 8* and *Who's Afraid of Virginia Woolf*. Taylor was also famous for her stormy, glamorous working relationship with—and marriage to—Richard Burton. In the 1980s, she worked in television and on stage; she now spends her time as an advocate for AIDS sufferers.

anne hollander
is the author of *Sex and Suits: the Evolution of Modern Dress*.

Photo: ARCHIVE PHOTOS

page 56

mother teresa
(1910–1997) of Calcutta joined the Sisters of Loretto in India in 1928. After receiving medical training in Paris, she opened her first school for destitute children in Calcutta in 1950. She opened House of the Dying in 1952 and established a colony for lepers, Shanti Nagar ("Town of Peace") in 1957. Mother Teresa was awarded the Pope John XXIII Peace Prize in 1971 and the Nobel Peace Prize in 1979.

becky benenate
is editorial director at New World Library and editor of *In the Heart of the World*, a book of Mother Teresa's writings.

Photo: MICHAEL COLLOPY

page 32

margaret thatcher
was Britain's first female prime minister. During her eleven years in office, she established a very personal, conservative political philosophy, popularly spoken of as "Thatcherism." In 1993 she published her bestselling autobiography, *The Downing Street Years 1973-1990*.

brenda maddox
writes a weekly media column for the *Times of London*.

Photo: MICHAEL COLLOPY

page 96

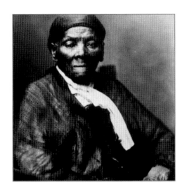

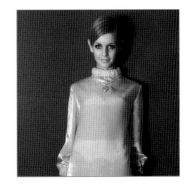

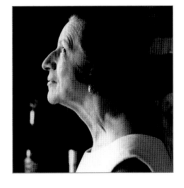

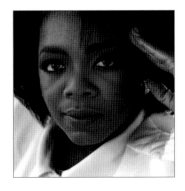

harriet tubman
(1820–1913) escaped slavery
as a young girl. She went on
to help free nearly 300 other
slaves, becoming known as the
"Moses of her people."
During the Civil War, Tubman
served as a Union spy and
recruiter of slave soldiers.
Later in life, she helped raise
money for a home for elderly
African Americans.

darlene clark hine
has authored numerous books
on African-American history.

Photo: SUPERSTOCK

page 64

twiggy,
originally Leslie Hornby,
was born in London. She was
launched into the fashion
world in 1966 by entrepreneur
Justin de Villeneuve, and
quickly shot to fame as a
fashion model. Her "Face of
1966" and waif-like figure
became the symbol of the
decade. Twiggy later proved
she could sing, dance, and act
in the films *The Boyfriend*
(1971) and *The Blues Brothers*
(1980).

susan cheever,
daughter of the novelist John
Cheever, is the author of sev-
eral books, including *Home
Before Dark.*

Photo: CECIL BEATON

page 30

diana vreeland
(1903–1989), the "high
priestess of style," was fashion
editor for *Harper's Bazaar* from
1937 to 1962 and editor of
Vogue from 1962 to 1971.
Always the trendsetter, she is
credited with coining the term
"beautiful people." After her
retirement, Vreeland served as
a special consultant to The
Costume Institute at The Met-
ropolitan Museum of Art in
New York.

nancy franklin
is a staff writer and theater
critic for *The New Yorker.*

Photo: ROWLAND SCHERMAN

page 68

oprah winfrey
began her career in broadcast-
ing at age 19 when she became
the first African-American
woman to anchor the news at
Nashville's WTV-TV. In
1984, she began her stun-
ningly popular confessional
talk show. She recently started
"Oprah's Book Club," promot-
ing such women writers as
Toni Morrison and Alice
Walker. Every book profiled
by the club has become a best-
seller.

maya angelou
is a writer, poet, performer,
and activist. Her best-known
work is the autobiographical
novel *I Know Why the Caged Bird
Sings.*

Photo: BRIAN LANKER

page 60

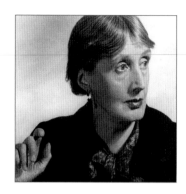

virginia woolf
(1882–1941) was an English
novelist, critic, and essayist,
who was known as an arche-
typal modernist. Her books
Mrs. Dalloway (1925) and *To the
Lighthouse* (1927) changed the
very form of the English
novel. Though she wrote pro-
lifically, Woolf was beset by
deep depressions and debili-
tating headaches. In 1941, she
forced a large stone into her
pocket and drowned herself in
the River Ouse.

claudia roth pierpont
is a regular contributor to
The New Yorker.

Photo: MAN RAY

page 62

babe didrikson zaharias
(1913–1956) was one of the
greatest athletes of all time.
As an Olympian in 1932, she
won both gold and silver
medals in track and field.
Turning to golf in 1933,
Zaharias won the U.S. Open
three times and founded the
Women's Professional Golf
League. She died in 1956 of
cancer.

susan e. cayleff
is a professor of women's
studies at San Diego State
and has written *Wash and Be
Healed: The Water-Cure Movement
and Women's Health.*

Photo: CORBIS-BETTMANN

page 80

anjelica huston
most recently directed the
Showtime movie adaptation
of Dorothy Allison's novel
Bastard Out of Carolina. She
won the Best Supporting
Actress Oscar at age 33 for
her role in *Prizzi's Honor* and
has appeared in numerous
films, including *The Grifters,
The Crossing Guard*, and *The
Dead*, which was directed by
her father, legendary film-
maker John Huston. She lives
with her husband, sculptor
Robert Graham, in Southern
California.

introduction, page x

index

credits

Marian Anderson piece by Jessye Norman. ©1996 by Jessye Norman. Reprinted by permission of *The New York Times Magazine*. Photograph © Archive Photos / PNI.

Excerpt from "Aung San Suu Kyi" by Gayle Kirshenbaum. Reprinted by permission of *Ms.* magazine, ©1996. Photograph © Robin Moyer.

Joan Baez excerpt from *The Hispanic 100: A Ranking of the Latino Men and Women Who Have Most Influenced American Thought and Culture* by Himilce Novas. ©1995 by Himilce Novas. Published by arrangement with Carol Publishing Group. A Citadel Press Book. Photograph © Michael Collopy.

Josephine Baker excerpt by Meg Cohen. ©1994 by Meg Cohen. Reprinted by permission of *Harper's Bazaar*. Photograph © UPI / Corbis-Bettmann.

Lucille Ball excerpt from *Women in Comedy* by Linda Martin. Published by arrangement with Carol Publishing Group. A Citadel Press Book. Photograph © Archive Photos / PNI.

Margaret Bourke-White excerpt by Vicki Goldberg. ©1986 by Vicki Goldberg. Reprinted by permission of HarperCollins. Photograph © UPI / Corbis-Bettmann.

"Rachel Carson" by Terry Tempest Williams. ©1994 by Terry Tempest Williams. Reprinted by permission of *Audubon*. Photograph © Underwood & Underwood / Corbis-Bettmann

Julia Child excerpt by Karen Lehrman. ©Sept 22, 1997, *U.S. News & World Report*. Photograph by Paul Child.

Excerpt from *Colette: A Taste for Life* by Yvonne Mitchell. ©1975 Yvonne Mitchell. Reprinted by permission of Harcourt Brace Jovanovich. Photograph © Cecil Beaton.

Imogen Cunningham excerpt from *After Ninety* by Margaretta Mitchell, University of Washington Press, 1977. Photograph © The Imogen Cunningham Trust.

Angela Davis by Kathleen Thompson from *Black Women in America: An Historical Encyclopedia*, Darlene Clark Hine, ed. Carlson Publishing Inc. 1993. Photograph © Brian Lanker.

Bette Davis piece by Janet Flanner originally appeared on 3/21/94 in *The New Yorker*. Reprinted by permission. Photograph © Archive Photos / PNI.

Princess Diana piece ©1997 by Francine du Plessix Gray. Reprinted by permission of Georges Borchardt, Inc., for the author. Originally appeared in *The New Yorker*. Photograph © Reuters / Corbis-Bettmann.

Amelia Earhart piece by Camille Paglia. ©1996 by Camille Paglia. Reprinted by permission of *The New York Times Magazine*. Photograph reprinted courtesy of SuperStock.

"Marian Wright Edelman: First Mom" by Richette L. Haywood. ©1996 Richette L. Haywood. Reprinted by permission of *Ebony*. Photograph © Michael Collopy.

"Ella in Wonderland" by Margo Jefferson. Copyright ©1996 by *The New York Times* Company. Reprinted by permission. Photograph © UPI / Corbis-Bettmann.

Anne Frank excerpt by Liv Ullman. ©1990 by Liv Ullman. Reprinted by permission of the author. Photograph reprinted courtesy of SuperStock.

Indira Gandhi excerpt by S. Susan Jane. ©1995 by S. Susan Jane, from *Herstory*. Reprinted by permission of Viking. Photograph © Dilip Mehta / CONTACT Press Images / PNI.

"Greta Garbo" reprinted courtesy of Isabella Rossellini. Photo Archive photos / PNI

Jane Goodall excerpt by Virginia Morrell ©1993. Reprinted with permission from *Science*, American Association for the Advancement of Science. Photograph © Michael Collopy.

"The Mastermind of a Media Empire," first appeared in *Working Woman*, November, 1989. Written by Mary Rowland. Reprinted with the permission of MacDonald Communications Corporation. ©1997 by MacDonald Communications Corporation. For subscriptions call 1-800-234-9675. Photograph reprinted courtesy of Lizzie Himmel.

Martha Graham piece reprinted by permission of Alma Guillermoprieto and the Watkins / Loomis Agency. Photograph © Yousuf Karsh.

Audrey Hepburn excerpt by Diane Johnson. ©1996 by Diane Johnson. Reprinted by permission of *The New York Times Magazine*. Photograph © Cecil Beaton.

Billie Holiday excerpt from *The Billie Holiday Companion* by Elizabeth Hardwick. ©1997 by Elizabeth Hardwick. Reprinted by permission of Schirmir / Simon & Schuster. Photograph © Jean Pierre Leloir.

Zora Neale Hurston excerpt from *I Love Myself When I'm Laughing...* by Alice Walker. ©1979 by Alice Walker. Reprinted by permission of Feminist Press. Photograph © Yale University Library.

Frida Kahlo excerpt from *Frida's Fiestas* by Guadalupe Rivera and Marie Pierce Colle. ©1994 by Guadalupe Rivera and Marie Pierce Colle. Reprinted by permission of Clarkson N. Potter, a division of Crown Publishers, Inc. Photograph © Corbis-Bettmann.

Helen Keller excerpt by Mary Jo Salter. ©1980 by Mary Jo Salter. Reprinted by permission of *The New York Times Magazine*. Photograph © Yousuf Karsh.

"Billie Jean King" by Sally Jenkins reprinted courtesy of *Sports Illustrated*, September 19, 1994. ©1994 Time, Inc. *Billie Jean King* by Sally Jenkins. All rights reserved. Photograph reprinted courtesy of Women's Sports Foundation.

Lynn Margulis excerpt by Elizabeth Royte. ©1996 by Elizabeth Royte. Reprinted by permission of *The New York Times Magazine*. Photograph © Richard Howard.

Beryl Markham excerpt from *A Natural History of Love* by Diane Ackerman. ©1994 by Diane Ackerman. Reprinted by permission of Random House. Photograph © UPI / Corbis-Bettmann.

Mary McCarthy piece, "The Company She Kept," excerpt from *Newsweek* 11/06/89 ©1989 *Newsweek*, Inc. All rights reserved. Reprinted by permission. Photograph © Corbis-Bettmann.

Golda Meir excerpt by Judy Gitenstein from *Herstory*. ©1995 by Judy Gitenstein. Reprinted by permission of Viking. Photograph © UPI / Corbis-Bettmann.

Marilyn Monroe excerpt by Gloria Steinem. ©1986 by Gloria Steinem. Reprinted by permission of Henry Holt. Photograph reprinted courtesy of SuperStock.

"Georgia O'Keeffe" from *The White Album* by Joan Didion. ©1979 by Joan Didion. Reprinted by permission of Farrar, Straus & Giroux, Inc. Photograph from the Alfred Stieglitz collection, gift of Georgia O'Keeffe Foundation, Sophie M. Friedman Fund and Lucy Dalbiac Luard Fund. Courtesy of Museum of Fine Arts, Boston.

Jacqueline Onassis excerpt by Marilyn Johnson ©1994 by Marilyn Johnson. Reprinted by permission of *Life*. Photograph ©1998 Jacques Lowe.

Anna Pavlova excerpt by Allegra Kent. ©1996 by Allegra Kent. Reprinted by permission of *The New York Times Magazine*. Photograph © Corbis.

Helen Prejean excerpt from "For Death Row, a Message of Love." ©Feb. 5, 1996, *U.S. News & World Report*. Photograph © Seana O'Sullivan.

Eleanor Roosevelt excerpt by Blanche Wiesen Cook. ©1984 by Blanche Wiesen Cook. Reprinted by permission of *Ms. Magazine*. Photograph reprinted courtesy of SuperStock.

Susan Sontag excerpt from "Premature Postmodern." Reprinted with permission from the October 16 1995 issue of *The Nation*. ©1995. Photograph ©1997 Annie Leibovitz CONTACT Press Images.

Gertrude Stein excerpt by Cynthia Ozick. ©1996 by Cynthia Ozick. Reprinted by permission of *The New York Times Magazine*. Photograph © Cecil Beaton.

Martha Stewart excerpt by Patricia McLaughlin. ©1996 Patricia McLaughlin. Reprinted by permission of *The New York Times Magazine*. Photograph © Jim Spellman / Corbis.

Elizabeth Taylor excerpt by Anne Hollander. ©1996 by Anne Hollander. Reprinted by permission of *The New York Times Magazine*. Photograph © Archive Photos / PNI.

"Mother Teresa" by Becky Benenate. ©1998 by Becky Benenate. Photograph © Michael Collopy.

Margaret Thatcher excerpt by Brenda Maddox. ©1996 by Brenda Maddox. Reprinted by permission of *The New York Times Magazine*. Photograph © Michael Collopy.

Harriet Tubman excerpt by Darlene Clark Hine. ©1993 by Darlene Clark Hine. Reprinted by permission of Carlson Publishing, Inc. Photograph reprinted courtesy of SuperStock.

Twiggy piece by Susan Cheever. ©1996 by Susan Cheever. Reprinted by permission of *The New York Times Magazine*. Photograph © Cecil Beaton.

Diana Vreeland excerpt, "Empress of Excess," reprinted by permission; ©1996 Nancy Franklin. Originally in *The New Yorker*. All rights reserved. Photograph by Rowland Scherman. Reprinted by permission of Ursus Inc.

"Women of the Year: Oprah Winfrey" by Maya Angelou reprinted by permission of *Ms.* magazine, ©1989. Photograph © Brian Lanker.

"Virginia Woolf" by Claudia Roth Pierpont. ©1996 by the *New York Times* Company. Reprinted by permission. Photograph © Corbis.

Excerpt from *Babe: The Life and Legend of Babe Didrikson Zaharias*. ©1995 by the Board of Trustees of the University of Illinois. Used with the permission of the University of Illinois Press. Photograph © UPI / Corbis-Bettmann.